Art Nouveau

Art Nouveau

Renato Barilli

Paul Hamlyn

LONDON · NEW YORK · SYDNEY · TORONTO

Translated by Raymond Rudorff from the Italian original

Il Liberty

© *1966 Fratelli Fabbri Editori, Milan*

This edition © 1969
The Hamlyn Publishing Group Limited
Hamlyn House,
The Centre, Feltham,
Middlesex

Text filmset by Yendall & Co. Ltd,
London

Printed in Italy by Fratelli Fabbri Editori,
Milan

INTRODUCTION

The term 'Art Nouveau' is applied to a style in architecture and the figurative and applied arts that flourished in the last decade of the 19th and the early years of the 20th century. It was preceded by a long preparatory phase, and was influential in many branches of art until the outbreak of the First World War. It was a phenomenon that occurred simultaneously throughout Western Europe and, like the Gothic, Baroque and Rococo movements, demonstrated the fundamental unity of Western European culture; it exemplified the continuous ferment of ideas and experimental cross-fertilisation taking place within the heart of that culture.

Like many earlier artistic movements, Art Nouveau has been known by several other names. The earliest, 'Liberty style', came from England and was adopted by the Italians—only to become completely meaningless to other countries, where the style became known as '*Art Nouveau*' (now the accepted term in England),

the 'modern style', the 'Secession' style, and the '*Jugendstil*'. It also gave rise to more picturesque and contingent appellations such as '*le style métro*' and '*style nouille*' in France, the 'modernist' style, the 'yachting' style and the 'floral' style.

Many of these terms originated almost casually and for obscure reasons; some were intended to be derisive—as 'Gothic' and 'Baroque' had been. 'Liberty style' was derived from the famous London shop, founded by Arthur Lasenby Liberty in 1875, which sold many articles (rings, brooches, etc.) in the new style at the end of the century. 'Art Nouveau' was the name given by the art dealer Bing to a shop specialising in the promotion of furniture, tapestries and other objects in the new *avant-garde* style. The term 'modern style' was widely used by the French in recognition of its largely English origin. But since one of the greatest achievements in the new style was the series of entrances the architect Guimard built for the Paris *métropolitain,* it was also called the '*style métro*'. Yet another term was used in France: the '*style nouille*' (literally 'noodle style'), inspired by the sinuous interlacing lines that were one of its distinguishing features. Later, Edmond de Goncourt, the elder of the two brothers who wrote the famous *Journals,* happened to visit Bing's shop, and remarked on the suitability of the style for the fanciful decoration of a cruising yacht. This gave birth to the term 'yachting style'. 'Jugend-

stil' was inspired by the title of the German review *Jugend*, first published in Munich in 1896, and 'Secession style' by the *Sezession*, an art movement in Munich, Berlin and Vienna which was in revolt against the official taste of the time and held many exhibitions.

The underlying motive of this art with so many names was to break decisively with the two main tendencies in Western art in the second half of the 19th century. Such a break was not be be made without artists being aware of their indebtedness to each of these tendencies.

In the first place Art Nouveau represented a breakaway from the 'historical' style that preceded it. This style embodied both a retrospective tendency and an often eclectic but cold and academic repetition of the most famous styles of the past. In contrast to this obsequious attitude towards the past and the traditions derived from it, Art Nouveau artists proclaimed their intention of basing their art on present reality, or even on futuristic visions of a reality to come. This explains why the various terms applied to them contain so many references to modernity, innovation and youth. They felt themselves to be young, poised on the threshold of a new era of research and experiment, freed from the shackles of the past and decisively turning to the future. When Art Nouveau did incorporate elements from past styles, they were styles so far removed in time (Medieval) or space (Chinese,

Japanese) from the Renaissance-Classical tradition that the result still seemed original and modern.

Art Nouveau had one thing in common with 19th-century academicism: both rejected naturalism, the other main tendency in Western art, which was in polemical opposition to academic art. Although Art Nouveau was intended to be both new and modern, its exponents were violently opposed to naturalism, opting instead for beauty, elegance and decorativeness—all qualities which the naturalists had renounced in favour of adhesion to the prosaic truth of everyday life.

Art Nouveau artists reproached the naturalists with being slavish imitators of nature and allowing themselves to be tied to factual data instead of making the effort to synthesise and project them in freer and more imaginative forms. Naturalists were also accused of being excessively interested in the sordid and plebeian, and of concentrating on gloomy, trite scenes from everyday life. This did not mean that all Art Nouveau artists wished to renounce all social responsibility; indeed, they were often highly conscious of their social task. But they did believe that the public duty of an artist was not so much to mirror the wretched facts of everyday life as to create an image of a world of universal happiness and beauty. In reality Art Nouveau was enjoyed by only a very restricted and overwhelmingly upper-middle-class

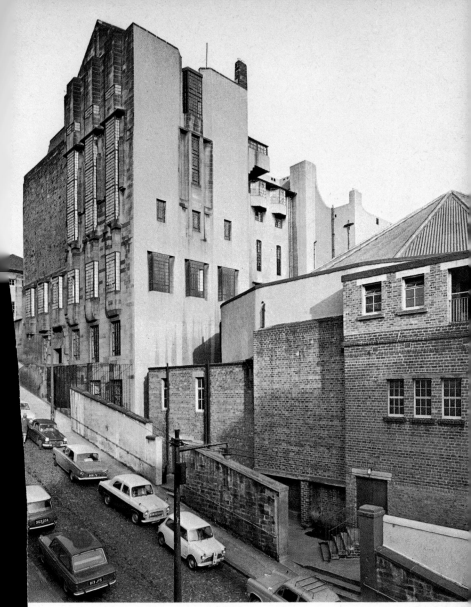

1. C. R. Mackintosh (1868-1928). School of Art. Glasgow.

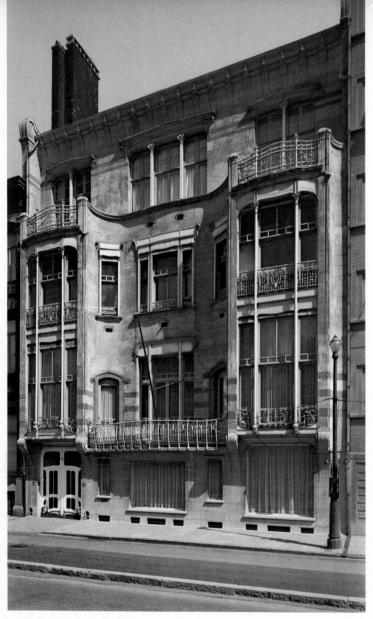

2. V. Horta (1861-1947). Maison Solvay (1895). Brussels.

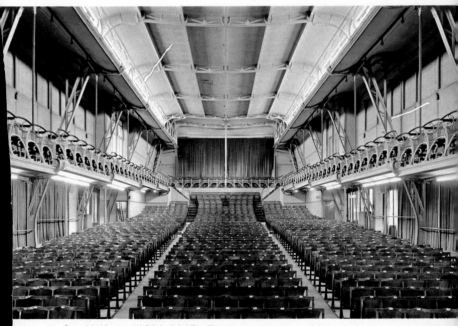

3. V. Horta (1861-1947). Theatre auditorium, Maison du Peuple. Brussels.

1. C. R. Mackintosh (1868-1928). School of Art. Glasgow. Mackintosh's most famous building. The angle from which the building has been photographed is the most suitable for bringing out the typically vertical style of the architect. Notice the Neo-Gothic elements, which have been redeemed by strikingly original innovations.

2. V. Horta (1861-1947). Maison Solvay (1895). Brussels. Perhaps Victor Horta's masterpiece. The typical curving, sinuous 'Belgian line' dominates the facade of the building with its in-and-out rhythm.

3. V. Horta (1861-1947). Theatre auditorium, Maison du Peuple. Brussels. In this building Horta proved that the Art Nouveau style was capable of being applied to a building of public and social utility without sacrificing its element of fantasy. Here the style has been carefully adapted to functional requirements.

4. O. Wagner (1841-1918). Maiolica house. Vienna. Here the head of the Viennese Art Nouveau school gave rein to certain characteristics that were later to be developed even further by Olbrich and Hoffmann: an almost Neo-Classical monumentality, and intense decoration of surfaces.

5. J. Hoffmann (1870-1956). Maison Stoclet (1905). Brussels. One of the great examples of Viennese Art Nouveau, even though it was built in Belgium. The counterpointing of large surface areas with fragile, pointed decorative fascia has been developed with the greatest coherence.

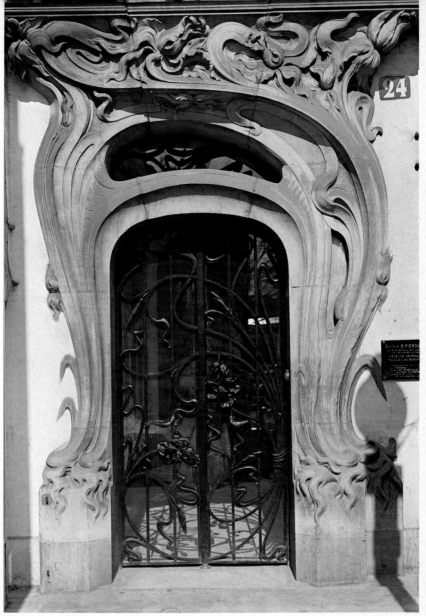

7.

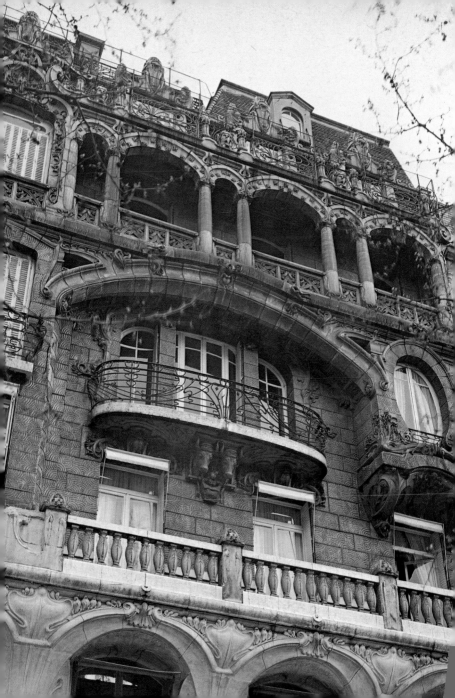

main emphasis of the Art Nouveau style was on biomorphic and phytomorphic shapes, and a building, a vase or a piece of furniture might be a masterpiece of coherence and unity; in many less successful cases, however, the artist failed to overcome more traditional constructive principles. The result was too often superficial decoration which easily degenerated into a suffocating 'art for art's sake' decoration.

Before concluding this introductory section, it should be pointed out that Art Nouveau was part of a larger trend. In particular, it was closely related to a movement in the novel, in poetry, in the theatre, and in music—a movement which sometimes produced a distinctive style of life among its practitioners and admirers—which was known as Symbolism or (whether used boastfully or reproachfully) the Decadent movement. Though it is difficult to make precise connections, the two movements are unmistakably related parts of the *Zeitgeist* of the late 19th and early 20th centuries.

ARCHITECTURE AND DESIGN

Such authorities on this period as Pevsner, Madsen, Schmultzer, Zevi and Benevolo have all agreed that English culture prepared the way for Art Nouveau. But they have also agreed that, for reasons we shall

8. Lavirotte (1864-1924). Private house. No. 29, Avenue Rapp. Paris.

go into later, it was not in England that the style reached maturity.

John Ruskin made the strongest attack on the 'historicising' tendency in art in the 19th century, and his teachings were taken up and applied by William Morris. The tendency under fire was, more precisely, the Neo-Renaissance style: Ruskin admired and Morris practised a kind of neo-Gothic and Medieval style. Their influence was a wholesome one, since it emphasised the virtues of honesty and stylistic coherence by which architects and craftsmen should be inspired. By putting forward a Medieval ideal, these two men were also propagandising a kind of art with no division of labour or responsibility between planner and executor, and no difference between basic structure and surface decoration; the logic inherent in the conception of a work must also appear in the decoration. Every part of the work must be executed by craftsmen, without recourse to stereotyped machine production.

This emphasis on the coherence and homogeneity of decorative and structural elements led Ruskin and Morris to some important conclusions. In the first place, they rejected the whole repertory of decorative motifs of the Renaissance type: rosettes, panoplies, fruits, *putti,* cupids, etc., were scorned as prefabricated objects destined for passive application to pre-existing structures. Although they insisted on themes taken

from nature, Ruskin and Morris attempted to formulate the clearest and most functional criteria for their construction, criteria that would then be valid for larger structures. In other words they began the process of extracting from natural forms those fluid linear motifs and plant shapes that were to be taken to their furthest extremes by the Art Nouveau artist.

They were not alone in the attempt, and had even been preceded by a number of specialists in ornamentation. In 1856, for example, Owen Jones had written a *Grammar of Ornament* in which he declared that 'the beauty of form is produced by lines born out of each other in gradual undulations.' A few years later Christopher Dresser wrote *General Principles of Ornament,* in which he proposed a gradation of linear motifs based on the principle that they became more interesting as they became more complicated and unexpected: 'the arc is the least interesting of the curves . . . A section of the outline of an ellipse is a more beautiful curve than that of the arc since its origin is less apparent, being traced from two centres. The curve that follows the shape of an egg is more subtle than the elliptical curve since it is traced from three centres.' This was the origin of the unexpected and eccentric linearism peculiar to Art Nouveau. Such teachings did not remain isolated but constituted a widespread programme put forward by the famous schools of design established by Henry Cole.

At this point it was the applied and useful arts rather than the fine arts that were affected. In 1862, when Dresser was writing his treatise, Morris founded a company in order to carry out his ideals: an integrated art in which the same motifs would be repeated on a tapestry, a stained-glass window or a vase, while at the same time the intrinsic properties of the material used would be respected; the hierarchy of major and minor arts was to disappear, as was the distinction between artist and craftsman. These were some of the fundamental aims, and they continued to be held by Art Nouveau artists.

All these theories resulted in the formation of a number of firms which aimed to promote and improve the applied arts. The most famous was the 'Arts and Crafts', founded in 1883; for ten years its exhibitions were outstanding displays of the most advanced designs. It was in a similar artistic climate that the famous Liberty shop was established. Yet another sign of the integration of the arts in England was the new style of illustrations for children's books begun by Kate Greenaway and continued by Morris's follower Walter Crane.

Despite these contributions towards the establishment of Art Nouveau, certain obstacles prevented Morris and his colleagues from realising their aims to the full; later their ideas were even opposed and condemned. Morris could never free himself from a

certain 'historicising' tendency, and the naturalistic motifs of some of his tapestries were designed with an analytical rigour and finickiness in striking contrast with the freedom and fluidity of Art Nouveau at its most mature. But medievalism was more than a stylistic trait: it was part of Morris's way of thinking, and led to him being regarded as obsessed with the past, or even as an opponent of anything new. The accusation seemed credible in view of his condemnation of the machine and industrial mass production and exaltation of the Medieval artisan. Such an attitude was obviously incompatible with the enthusiasm for the modern characteristic of Art Nouveau, even though the question of its relationship with industry was a tricky one. Art Nouveau artists did not in principle oppose the industrial production of objects and utensils, but they disliked excessive simplification and insisted on maintaining a certain vitalistic-ornamental element which was often difficult to guarantee in mass production.

What has been said about Morris, Jones and Dresser also holds good for the architects of their generation. The most famous was Philip Webb, who built the Red House for Morris, who wanted a model dwelling and a centre for his artistic, political and social activities. The building has a slightly Gothic air which is in harmony with the stress on simple functional lines, all in sober good taste. A generation of

9. H. Van de Velde (1863-1948). House of the architect, Bloemenwerf (1896). Uccle, Brussels.

10. H. Guimard (1867-1942). Private house. No. 60, Rue de La Fontaine. Paris.

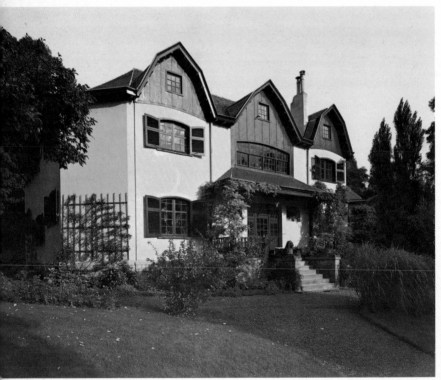

9.

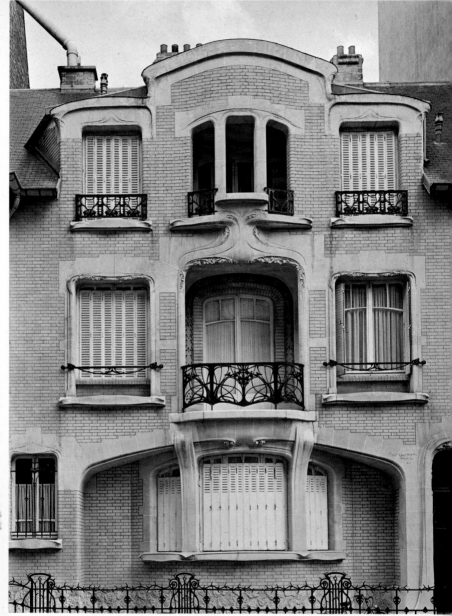

10.

9.　H. Van de Velde (1863-1948). House of the architect at Bloemenwerf (1896). Uccle, Brussels. This is perhaps the most typical example of a quite widespread tendency in the art and architecture of the time: to build one's own house as a tangible symbol of one's philosophy and ideals. Van de Velde's house illustrates the then not infrequent co-existence of sinuous and clearly functional motifs.

10.　H. Guimard (1867-1942). Private house. No. 60, Rue de La Fontaine. Paris. The French architect has taken up the 'Belgian line' but has used it in a more nervous manner, striving for the more eccentric and picturesque effects inherent in the new style.

11.　A. Gaudí (1852-1926). Casa Milà (1905-1910). Barcelona. The most famous and complex of all the civil buildings designed by the great Catalan architect. The entire structure is dominated by a sinuous, snake-like movement. The building also represents a radical rejection of classic symmetry, with doors and windows set in a characteristically eccentric order.

12.　A. Gaudí (1852-1926). La Sagrada Familia (1909-1926). Barcelona. Gaudí devoted almost twenty years to this grandiose construction but only succeeded in completing one of its four projected facades. Numerous designs and models have, however, survived to give an idea of the general plan of the building. Although at first sight designed according to a Neo-Gothic plan, it was in fact inspired by a highly original and personal criteria.

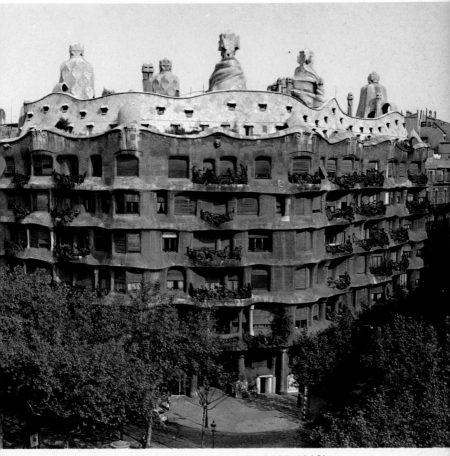

11. A. Gaudí (1852-1926). Casa Milà (1905-1910).
Barcelona.

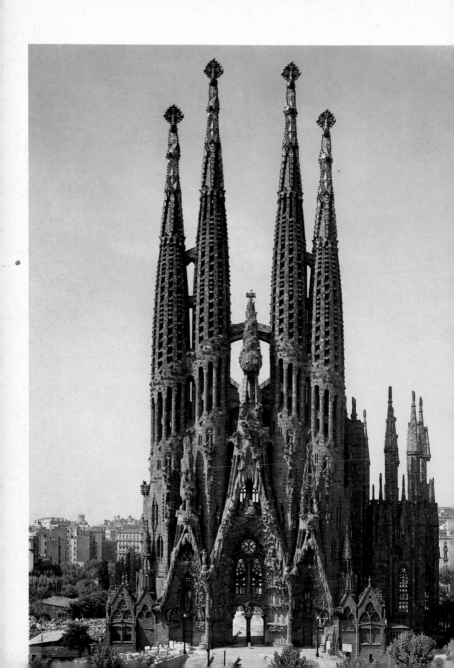

younger architects and designers, Mackmurdo, Voysey and Ashbee, were responsible for the further development of the potential Art Nouveau elements in Morris's works and ideas. The designs for textiles and wallpaper by Mackmurdo and Voysey were freer from the constraints of the Neo-Gothic style, showing more concern with synthesis and structural essentials, and employing increasingly audacious curvilinear elements. Such buildings as the many private villas which made Voysey famous were henceforth free from all archaising and Neo-Gothic influences; they were designed with clear-cut, economical lines. Only occasionally were the lines broken by some slight eccentricity in the placing of doors and windows— but such eccentricities were always so cautious and contained that they had little in common with the tormented and complex shapes of typical Art Nouveau buildings. (As a matter of fact Voysey's buildings are closer to the functionalism and rationalism of the architecture of 1910-1920 and Frank Lloyd Wright's experiments in the United States.) On the rare occasions when authentic Art Nouveau products did appear in England, they did so outside the Arts and Crafts movement (and often in opposition to it) and rather later than on the Continent. The main British achievements in Art Nouveau were buildings and furnishings by the Scot Charles Rennie Mackintosh and illustrations by the heterodox Aubrey Beardsley.

12. A. Gaudí (1852-1926). La Sagrada Familia (1909-1926). Barcelona.

By an irony of fate, the most striking, complex, talented and inventive figure in the whole Art Nouveau movement—and the first in chronological order —appeared in a country utterly remote from the ethos of English taste and culture. This was Antonio Gaudí, who was active in his native Barcelona— which he never left and where he carried out nearly all his designs—as early as the 1880s. Gaudí's appearance was not a miraculous coincidence: in his formative years he had been influenced by the teachings of Ruskin and Morris. Another relevant influence on his work was that of the French architect Viollet-le-Duc, in many respects the French counterpart of Ruskin and Morris. Viollet-le-Duc worked in a Neo-Gothic style, employing it in order to demonstrate certain audacious structural solutions. These were emphasised by a widespread use of metal, which the architect often left bare in his buildings—a marked contrast with the prescribed decoration for covering the structure. Consequently, even Gaudí's earliest buildings can be recognised by their vaguely Neo-Gothic verticalism, as in his Casa Vicens, the Palacio Güel and the college of the Sisters of Teresa. But such Gothicism was more apparent than real, for closer examination reveals that Gaudí replaced the Gothic pointed arch with more original parabolic arches, following Dresser's injunction to use eccentric and difficult curves at every opportunity. This parabolic

emphasis, which was so dear to Gaudí and other Art Nouveau practitioners, indicated his preference for natural forms in which continuous linear rhythms predominate over broken rhythms. The insistent motif of arcades divided into two or three sections by mullions also demonstrated that Gaudí's 'Gothic' style had given way to a fantastically capricious articulation of structural elements. This verticality of structures, often underlined by the use of uncovered brick, was accompanied by decoration with maiolica tiles composing a brilliant and multicoloured mosaic. At first sight Gaudí's architecture might seem to reveal an archaising tendency, since this use of polychrome materials had been a characteristic of the traditional Spanish *mudejar* style. But in fact the audacity and decorative exuberance with which Gaudí treated this technique gave it a peculiar character of its own, comparable only with a few similar works produced by the Viennese Art Nouveau school. In other later works, such as the Casa Batlló, Casa Milá and Parque Güell, Gaudí seems to have concentrated on the other aspect of Art Nouveau vitalism: undulating lines and swelling or concave wall surfaces with decoration in relief. He boldly based his vast and ponderous buildings on biomorphic shapes, using designs which—however eccentric at first sight—never worked against the logic of the materials used, or, as Roberto Pane has shown in a recent study,

against a paradoxical and original functionalism. Gaudí—and Art Nouveau artists in general—did not propose to create an artificial and arbitrary world; on the contrary, they wished to render the essence of natural creation at the moment of greatest tension and exuberance.

Gaudí showed himself to be a faithful follower of Morris in his integration of macrostructure with microstructure. He did not confine himself to the architectonics of a building, but designed the accessories and details—the railings, the balustrades, the gratings, the lift, the door-handles, the furnishings, the furniture and windows. He very often supervised their material execution as well, ensuring that each part had sufficient vitality to form a satisfactory element in the totality, sharing and complementing its rhythms. These methods, like Gaudí's scrupulous respect for his materials, were the same as Morris's, but Gaudí's aims were wholeheartedly modern. Gaudí, unlike Morris, never indulged in nostalgia and simple-minded Medievalism. His last great achievement, the unfinished temple of the Sacred Family, looks 'Gothic' at first sight; but in reality the design of its spires consists of a series of curves based on complex mathematical equations never before applied in architecture.

Because he was a lone wolf throughout his life, and because his talent was so protean, Gaudí has tempted

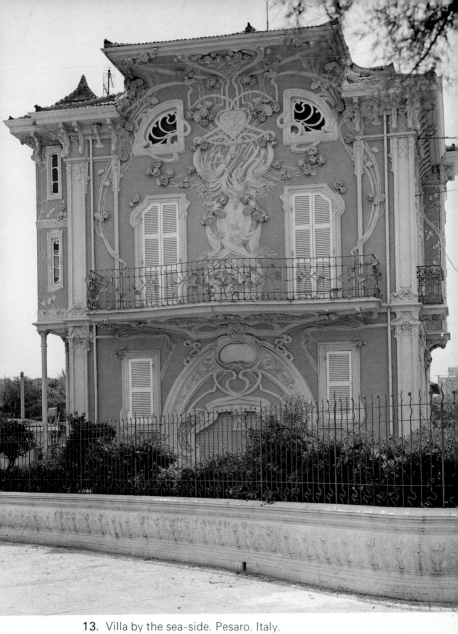

13. Villa by the sea-side. Pesaro. Italy.

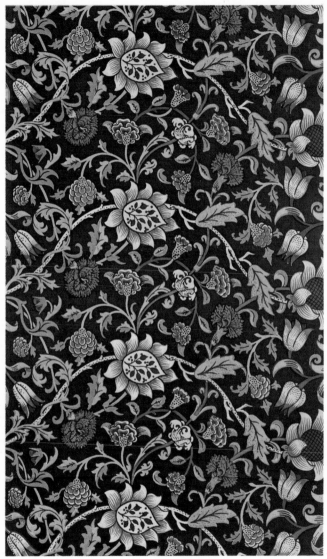

14. W. Morris (1834-1896). Chintz. Victoria and Albert Museum, London. Photo John Webb.

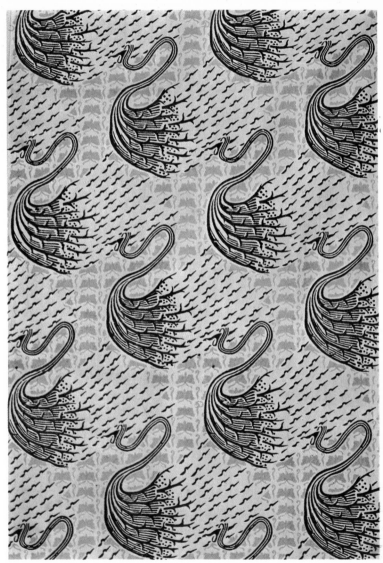

15. H. Mackmurdo (1852-1942). Textile design (1884).
William Morris Gallery, London.

13. Villa by the sea-side. Pesaro. Italy. An example of Art Nouveau in architecture in which the style has been confined almost entirely to the surface decoration and only marginally to the actual structure. The refined decoration is heightened by the rich and imaginative use of floral motifs in skilfully interlacing patterns.

14. W. Morris (1834-1896). Chintz. Victoria and Albert Museum, London. Photo John Webb. Typical of the type of decorative pattern championed by Morris. The decoration is fresh and lively, free from any Renaissance or academic inspiration, and seems rather to have been inspired by Neo-Gothic forms. On the other hand, the design is still meticulous and detailed.

15. H. Mackmurdo (1852-1942). Textile design (1884). The William Morris Gallery, London. The architect and designer Mackmurdo belonged to the generation before that of his master Morris, and had thus begun to feel the impact of the new 'synthetic' spirit of the late 19th century. In consequence a greater striving after stylisation and synthesis became apparent in his work.

16. E. Grasset (1841-1917). Tapestry (c. 1899). Bertonati Collection, Milan. Even here the treatment of the figures and landscape is dominated by the synthetic style. But Grasset was not a particularly audacious 'synthetist', and his design remains rather academic and even traditional.

17. A. Gaudí (1852-1926). Detail of the terrace-belvedere. Parque Güell, Barcelona. The uncoiling parapet crowning the terrace is an example of how maiolica can be used to give a harmonious pictorial effect. The decorative compositions which give it such a lively appearance have been recognised as precursors of the modern *collage*.

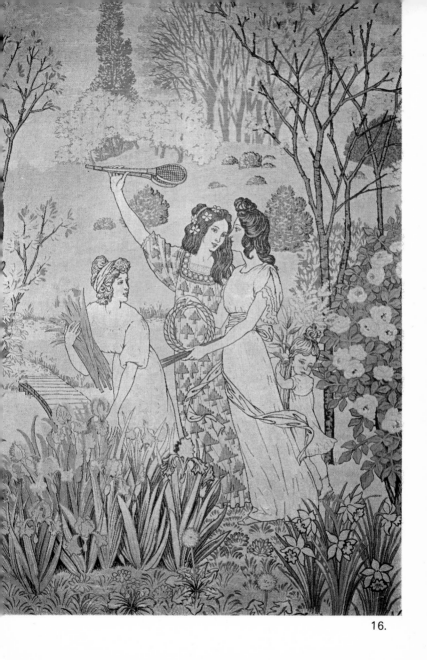

16.

17. A. Gaudí (1852-1926). Detail of the terrace-belvedere. Parque Güell, Barcelona.

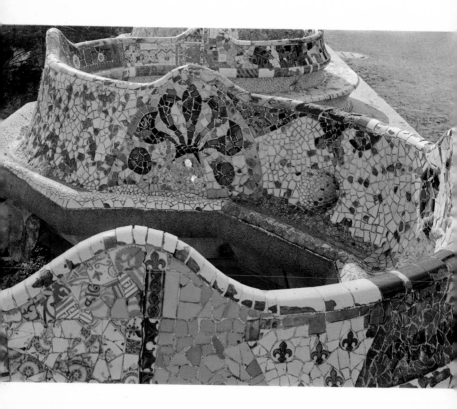

more than one critic to describe him as outside the Art Nouveau movement—as a forerunner of such movements as Expressionism or Surrealism, or else as a kind of Neo-Baroque archaiser. In fact, every fundamental trait of Gaudí's work is included in the repertoire of Art Nouveau. The movement would have been severely impoverished if it had been deprived of an interpreter of such power.

On the other hand, it must be recognised that Gaudí influenced only a few Spanish pupils and followers; his example did not affect any other European centre. The fullest manifestations of Art Nouveau in architecture occurred in Belgium, and in particular in the works of two exceptional figures active in the new style during the 1890s: Victor Horta and Henri Van de Velde. Horta was the architect of such justly famous buildings as the Maison Tassel (1892-1893), the Maison Solvay (1895), the Maison Horta and the Maison du Peuple, all in Brussels. These buildings display the 'Belgian line' or 'lace line' or 'whiplash line': entwined, spiralform, flexuous lines like the tendrils of a vine. A study of Horta's buildings reveals their structural coherence and homogeneity: the same sinuous linear principle governs both the supporting structure and the decorative elements. The helicoidal design of a staircase corresponds with that of its balustrade, the iron framework (left bare in accordance with Viollet-le-Duc's teachings) and the

knots of lianas which carry the design over the walls and the floor. Even the door-handles were so designed that they participated in the dominating rhythm of the whole structure. Despite the intense vitality and strong rhythms of Horta's works, the overall effect was one of balance. His talent was not as unexpected and fertile as Gaudí's, for once he had discovered his leitmotiv, the 'noose-like line', he extended it throughout the design. This perhaps explains why the teaching of the Belgian architect found such a large audience (apart from the fact that he was working in the capital city of his country).

Such an exquisite and elegant linear design was not employed for the socially privileged alone. Horta did not hesitate to apply it to a building intended for a wider public—for example the Maison du Peuple that he was commissioned to build by the Belgian workers' movement, which was one of the most advanced and most active in Europe. This building proved that Art Nouveau really could be an art for everyone, without sacrificing its characteristic elegance and refinement; in such buildings it was up to the artist to apply them with sobriety and restraint.

The influence of Horta's compatriot, Van de Velde, was equally fundamental and far-reaching. Although his personality was less intense than Horta's, he was notable for his variety of interests and his gradual, articulated development from Art Nouveau to a style

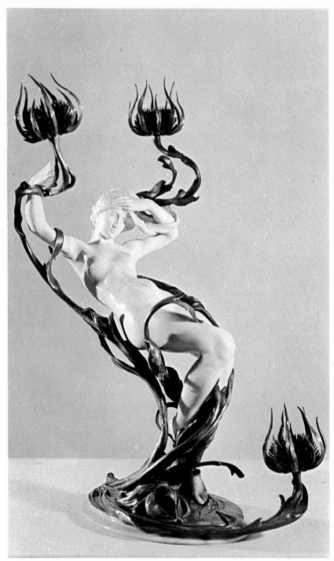

18. F. Hoosemans. Candle-holder (1900). Kunstgewerbe-
museum, Hamburg.

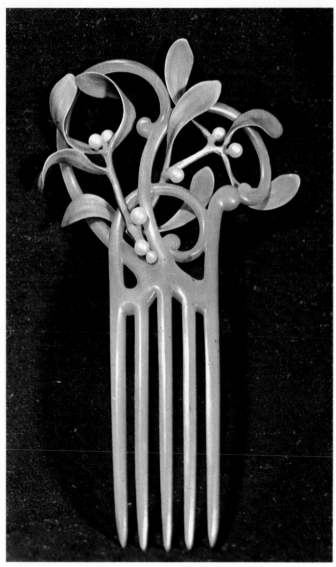

19. Horn comb with enamel, gold and pearl decoration. Made by Vever (*c.* 1900). Kunstgewerbemuseum, Hamburg.

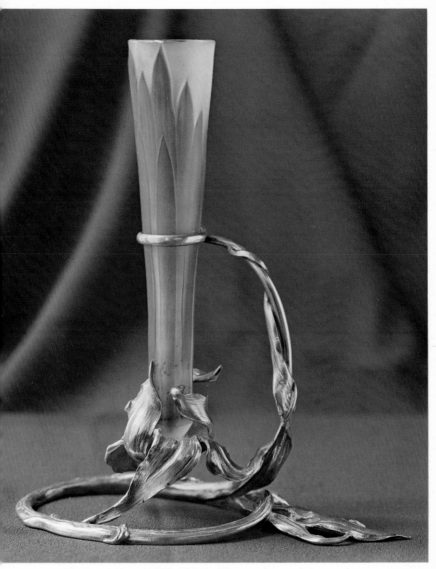

20. P. Wolfers (1858-1929). Silver and crystal vase.
L. Wittamen-De Camps Collection, Brussels.

18. F. Hoosemans. Candle-holder (1900). Kunstgewerbe-museum, Hamburg. The human figure is still treated in an academic and 'historicising' manner but it has lost its autonomy and become incorporated in a floral motif which is the most important and meaningful part of the work.

19. Horn comb with enamel, gold and pearl decoration. Made by the Paris firm of Vever (*c*. 1900). Kunstgewerbe-museum, Hamburg. The human figure has completely disappeared, and the design is completely dominated by the plant motif, although the decoration has been adapted to the function of comb.

20. P. Wolfers (1858-1929). Silver and crystal vase. L. Wittamen-De Camps Collection, Brussels. Each element of the vase has been transformed into a motif which has its equivalent in the plant-world: roots, leaves and corolla.

21. P. Wolfers (1858-1929). Silver egg-cups. L. Wittamen-De Camps Collection, Brussels. Another example of the complete transformation of an object into plant shapes. Wolfers distinguished himself by working in this vein with silver and the example reproduced is a perfect specimen of Art Nouveau silver ware.

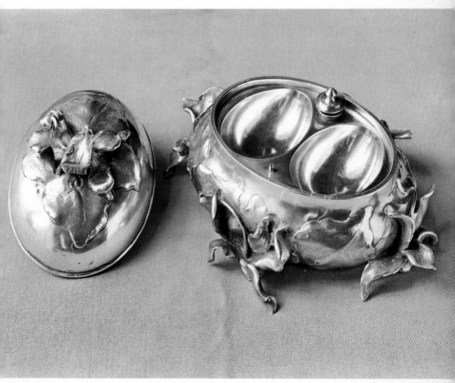

21.

which anticipated many of the characteristic features of 20th-century functionalism. Van de Velde made his debut as a painter and graphic artist, and from the beginning his work contained the fluid curvilinear rhythms of Art Nouveau. His first opportunity as a planner and designer came when he decided to build himself a model house at Bloemenwerf (Uccle, near Brussels). This was a striking example of the tendency of artists of this period to express their talent in the creation of their own homes—making the home a kind of tangible artistic manifesto. Van de Velde did not confine himself to the architectural design of the house: he also designed the furnishings and furniture, and even the clothes to be worn by his wife. There could be no better example of the aspiration towards an integrated and stylistically coherent environment. The furnishings attracted attention, and interested the dealer Bing, who commissioned Van de Velde to make some furniture for his shop. The critic Meier-Graefe was also attracted by his achievements, and made Van de Velde known in Germany, which soon became the centre of his activities (especially the Folkwang Museum in Aachen and the Werkbund Theatre in Cologne). In a short time he became the leader of the German movement for the renewal of the applied arts which led in 1907 to the establishment of a Werkbund, the German equivalent of the older British Arts and Crafts movement.

Apart from his work as a designer, Van de Velde owed his eminent position to his extensive activities as a theoretician and polemicist, which made him a sort of Continental William Morris. Working ten years later than his illustrious predecessor, he was able to make a critical evaluation of the latter's attitudes. The writings of the Belgian artist display two apparently conflicting tendencies. On one hand they contain statements which suggest that Van de Velde was a forerunner of the functionalism and rationalism of the architecture of the 1910s and 1920s: 'The character of all my artisanal and ornamental work is derived from a unique source: reason, and rationality in aspect and in essence' *(For the New Style)*. He also speaks of an 'irresistible aspiration towards clear-cut, healthy forms', and of objects in which structure and external appearance 'would be perfectly adapted to their purpose and their natural form'. But when he had to define the essence of the 'new' decorative art of which he was a protagonist, he declared that 'in it, forces operate just as in nature, like the wind, fire and water'. Such a statement demonstrated that his art contained those qualities of vitalism or distilled, quintessential naturalism which characterised authentic Art Nouveau. And, if Van de Velde did gradually modify his use of curved lines in the course of his career, they never altogether disappeared from his work. He displayed the same ultimate adherence to

Art Nouveau ideals with regard to the crucial problem of the relationship between art and industry. As early as 1897 he was affirming that one must 'avoid in furniture all that cannot be produced by large-scale industry'. But in 1914, in a famous meeting of the German Werkbund, he clashed with Muthesius, upholding the artistic dignity of the designer against his opponent's insistence that the designer submit to the limitations imposed by mass-production.

It may be said then, that two different impulses coexisted in Van de Velde: the one warm, vital and organic, the other limpid, clear-cut and functional. These impulses were present in varying degrees in the work of other artists of the period. In Germany, for example, the development of August Endell and Peter Behrens presents a striking contrast. It was Endell who decorated the facade of the Elvira photographic studio at Munich (now unhappily destroyed) with a stylised rendering of tumultuous and unchained natural forces in mural decorations in which stormy waves and turbulent whirlwinds could be vaguely glimpsed. Behrens too had begun by working along purely decorative lines, only to strike out resolutely in the other direction; his famous AEG turbine factory of 1909, for example, boldly anticipates the rationalism of Gropius.

In France a similar difference existed between the contrasting personalities of Hector Guimard and

Auguste Perret. France was the main stronghold of the historicising tendency in architecture at its coldest and most mechanical. The most famous example is Charles Garnier's famous and monstrous Grand Opera (1861-1875). In spite of this, Viollet-le-Duc's theories concerning iron structures bore fruit in 1887 with the building of the Eiffel Tower—a work which had none of the characteristics of Art Nouveau but which prepared the ground for it by setting an example of modernistic and futuristic building.

Hector Guimard is generally recognised as the greatest exponent of French Art Nouveau. In such works as the Castel Béranger, the Castel Henriette, the auditorium of the Palais Humbert at Romans, and the entrances for the Paris Métro, the French architect proved himself the readiest of the Continental architects to adopt the 'lace-like line' proposed by Horta. He was also the most capable of withstanding comparison with the original model, being inferior to Horta in neither audacity nor inventive genius. In his work the exuberantly organic element is even more marked, with the result that modern design owes him one of the most intense examples of systematic phytomorphism in the whole Art Nouveau period.

Auguste Perret followed a completely opposite path, especially in two buildings in Paris: a block of flats in the Rue Franklin, and the Garage Ponthieu. In both buildings the bareness and geometrical rigour

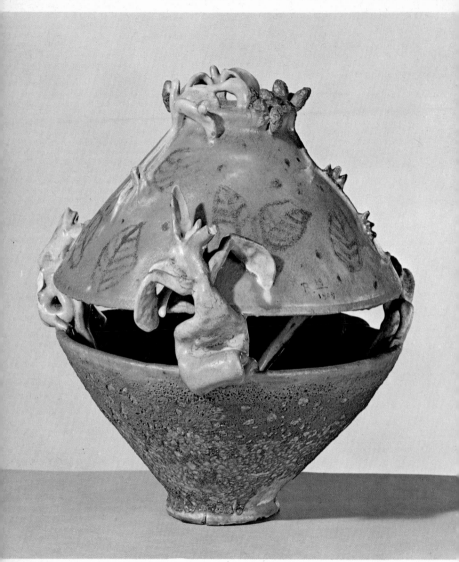

22.

22. J. F. Willumsen (1863-1958). Double vase in earthenware (1892). Det danske Kunstindustrimuseum, Copenhagen. The Danish artist Willumsen had worked closely with Gauguin at the time of the school of Pont-Aven, and had been influenced by him for some time before going on to work in another vein. In particular, he agreed with Gauguin in despising pure easel painting and turned to the applied arts, making vases, funerary urns and bas-reliefs.

23. E. Gallé (1846-1906). Vase (*c.* 1900). Kunstgewerbemuseum, Hamburg. Gallé was one of the outstanding figures in the French Art Nouveau movement. He applied the criteria of Art Nouveau to the creation of polychrome glass vases. The surfaces invariably featured flowers or insects, which were treated with an intensity which raised them above the level of the purely ornamental. The shape of the vase was strikingly renewed.

24. E. Gallé (1846-1906). Iris. Yellow and polychrome glass mounted in bronze. Musée Galliera, Paris. Another example of Gallé's very large production. He gathered other artists around him to form the School of Nancy, which was active not only in the manufacture of glassware but also in furniture and interior decoration in the new style.

25. E. Gallé (1846-1906). Glass vase. Kunstgewerbemuseum, Hamburg. The almost classic form of the vase has been largely offset by the floral motifs on the surface; they give life to the whole design.

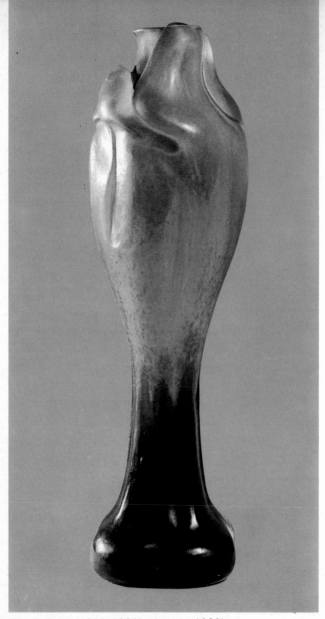

23. E. Gallé (1846-1906). Vase (*c.* 1900).
Kunstgewerbemuseum, Hamburg.

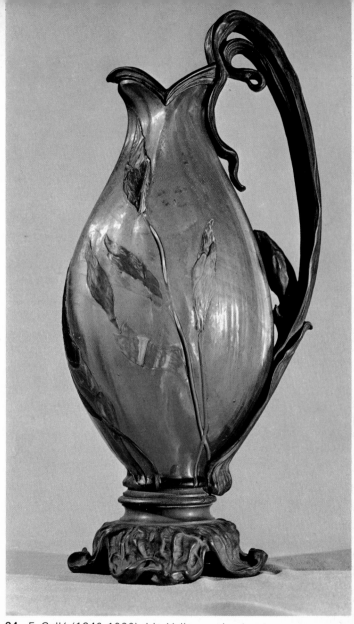

24. E. Gallé (1846-1906). Iris. Yellow and poly-
chrome glass, mounted in bronze. Musée
Galliera, Paris.

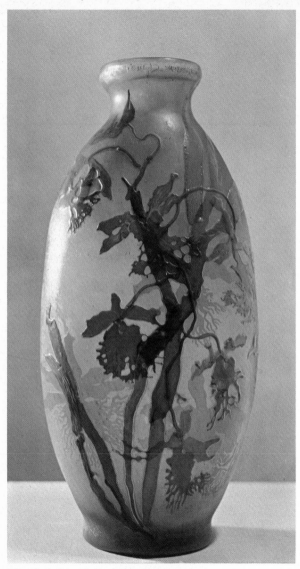

25. E. Gallé (1846-1906). Glass vase.
Kunstgewerbemuseum, Hamburg.

of the framework clearly anticipated the rationalist school of architecture of the early 20th century. The few elements which were still clearly Art Nouveau in inspiration were relegated to the role of mere accessories. In the building in the Rue Franklin they were confined to some floral decoration on part of the wall surface. Only a small part: there was an audacious and 'functional' prevalence of plain surfaces. In the Garage Ponthieu a central rose-window was the only surviving decorative note.

Another figure who belongs wholly to the period was the Scotsman Charles Rennie Mackintosh, who created what were perhaps the only authentic examples of British Art Nouveau architecture. The external appearance of Mackintosh's buildings—the most famous being the Glasgow School of Art—does not seem to confirm such a judgement, since the architect does not appear to stray very far from the Webb-Voysey tradition: Neo-Gothic perpendicularity combined with an eccentric placing of windows and doors, the whole being moderated by a good solid dose of common sense and simplification. But the occasional vertical emphasis and eccentricity of the windows in Mackintosh's structures defied the 'golden measure' of English architectural tradition, thus making it impossible for him to follow its main line of development and anticipate the rationalism of the 20th century. This impression is even more strikingly confirmed by

the interiors and furnishings, in which Mackintosh displayed his talent to the full. If for Horta and Guimard the leitmotiv was a 'lace-like line' with spiral undulations, for Mackintosh it was a tall, slender, 'stem-like' line which favoured the use of verticals. This was not, as might at first sight be thought, a lucid and rational motif free from all organic-decorative complexities. Mackintosh's stem-like line was really a phytomorphic motif, the linear verticality of his designs breaking out into patterns of circumvolutions and a variety of articulated elements. Mackintosh, like other typical representatives of Art Nouveau, generally ignored right-angled intersections of lines and rectangular shapes, preferring the richness of arabesque patterns.

It is logical to turn from Mackintosh, and Britain in general, to the situation in Vienna, for Austrian artists were deeply and directly influenced by ideas from across the Channel. This long-distance relationship was made possible by the fact that Viennese Art Nouveau artists, like their British counterparts, did not succumb to the attractions of the 'Belgian Line'. Instead of working with curvilinear undulating lines, they preferred to compose vertical patterns emphasising large areas of wall-space broken only by the eccentric disposition of doors and windows.

The tutelary figure presiding over Viennese architecture was Otto Wagner, whose school produced

two of the most representative exponents of the new style: Olbrich and Hoffmann. Wagner, especially at the beginning of his career, worked largely in the most dangerous type of historicising style: a Neo-Classical monumentalism with heavy semicircular arches, massive colonnades and gigantic pediments covering the facades of his buildings. Curiously enough, he made increasing use of exotic monumental motifs taken from the art of ancient Egypt and Mesopotamia. Such a combination was one of the most typical traits of the Secession style. There was something forbidding about the Secession style, and such an accumulation of monumental themes of different origins suggests heaviness and solemnity; but it should be added that even such a display of rhetoric concealed elements and values that were decidedly futuristic in outlook. In some buildings of Wagner's mature period (the Metropolitan stations, the Postal Bank and the University Library) the square-cut monumental blocks of the buildings had a structural rigour and functionalism which anticipated the most imposing public buildings of 20th-century rationalist architects. But in these years it was only Sullivan and a few others in the United States who designed and carried out buildings of the utmost simplicity; neither Wagner nor his pupils broke completely new ground. Wagner adhered to Art Nouveau because he wished to enrich even the most tensely functional designs

with exotic elements, and with an intensive decoration for which the vast wall surfaces of his buildings were well suited.

The youth of Wagner's disciples, Olbrich and Hoff-mann, exempted them from the necessity of a long and laborious emancipation from the Neo-Classical archaising style which had dominated their master. Olbrich gave his name to an artists' colony built at Darmstadt and commissioned by the Prince of Essen. This was appropriate, for his whole life (prematurely ended in 1908) was dedicated to a single purpose: to create a completely 'integrated' environment, a total-ity in which every detail should be planned and yet should not be restrictive. The Olbrich Haus, the Palace of Expositions, and the Hochzeitturm were the most important works of this young architect, who aimed to combine exotic monumentalism, areas of undecorated space and vibrant multi-coloured decora-tive detail. His decorative style had close affinities with the dazzling, mosaic-like patterns of colour that characterised the paintings of Gustav Klimt, the most famous artist of the Viennese Secession.

Hoffmann also repeated and accentuated the most striking and modern elements of Wagner's rich repertory. In his two most famous buildings, the Palais Stoclet at Brussels and the Purkersdorf Sana-torium, he made even greater use than Wagner of clear-cut, wide, plain surfaces, using them as a con-

26. E. Gallé (1846-1906). Vase. Crystal with chalcedony tints. Musée Galliera, Paris.

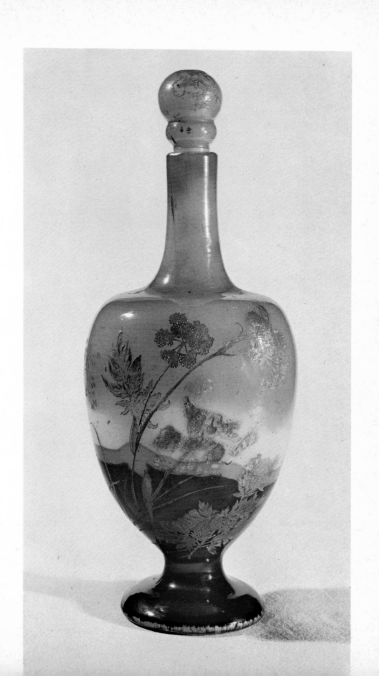

27. R. Lalique (1860-1945). Siren-shaped diadem. Musée des Arts Décoratifs, Paris.

28. R. Lalique (1860-1945). Peacock brooch. Musée des Arts Décoratifs. Paris.

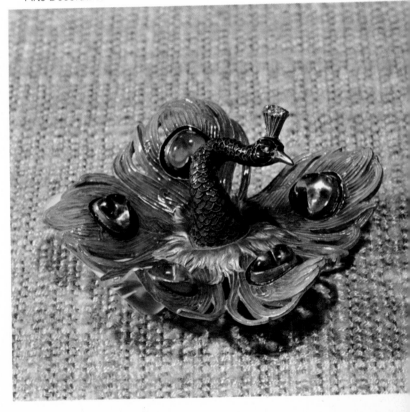

26. E. Gallé (1846-1906). Vase in crystal with chalcedony tints. Musée Galliera, Paris. Gallé did not always favour clear-cut designs with closed lines, as may be seen from this work. He sometimes sought for blurred, highly evocative effects reminiscent of the paintings of Odilon Redon.

27. R. Lalique (1860-1945). Siren-shaped diadem. Musée des Arts Décoratifs, Paris. Lalique was one of those Art Nouveau artists who succeeded in raising the minor arts to the level of the major arts. In his hands a piece of jewellery like the one illustrated became a complex composition, with a wonderful three-dimensional quality.

28. R. Lalique (1860-1945). Peacock brooch. Musée des Arts Décoratifs, Paris. The peacock motif was particularly popular with Art Nouveau craftsmen because of its great decorative possibilities. This example is one of the most exquisite variations upon the theme.

29. R. Lalique (1860-1945). Vase. Det Danske Kunstindustri-museum, Copenhagen. Even when he worked in other arts than jewellery, Lalique never lost his gift for creating intricate and fantastic forms.

30. R. Lalique (1860-1945). Decorated Cup. Österreichisches Museum für angewandte Kunst, Vienna.

30.　R. Lalique (1860-1945). Decorated cup. Österreichisches Museum für angewandte Kunst, Vienna. Lalique's talent for creating ramifying, swarming images has never been better exemplified than here.

31.　A. Mucha (1860-1939). Pencil-holder for 'La Plume'. Galleria del Levante, Milan. Mucha, who was best known as a poster designer, has here decorated a practical object with his famous prototype of the beautiful, mysterious and enigmatic woman. The long flowing hair of the woman has a freedom of line almost never found in his graphic work.

32.　L. C. Tiffany (1848-1933). Glass vase (*c*. 1900). Museum of Modern Art, New York. The vase is entirely designed after a flower, with the various parts—the bulb, the stem, even the unfolding corolla—perfectly imitated. The work was in perfect harmony with the plant-obsessed spirit of Art Nouveau.

33.　L. C. Tiffany (1848-1933). Glass vase (*c*. 1900). Museum of Modern Art, New York. Like Gallé, the New York craftsman Tiffany succeeded in making glass vases works of art. Unlike Gallé, he concentrated on renewing the external form of the object, producing bold, unusual shapes inspired by the strangest creations of the animal and plant kingdom.

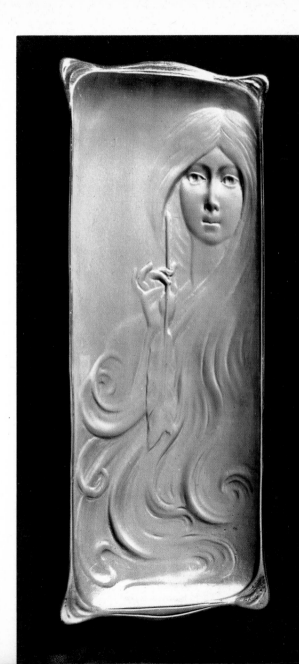

31.

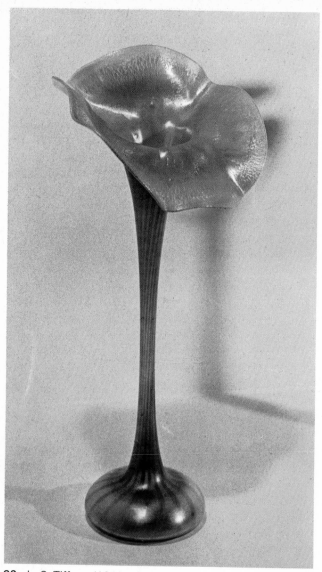

32. L. C. Tiffany (1848-1933). Glass vase
(*c.* 1900). Museum of Modern Art, New York.

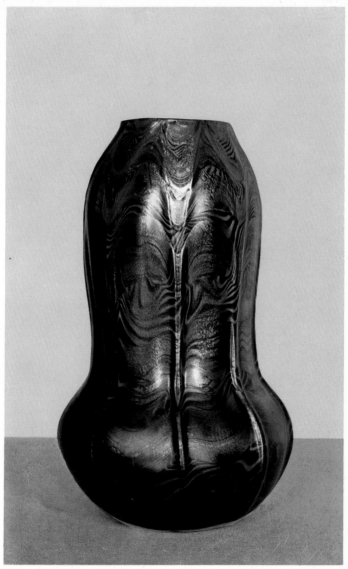

33. L. C. Tiffany (1848-1933). Glass vase (*c.* 1900).
Museum of Modern Art, New York.

Christopher Dresser, an observant theoretician of modern decorative styles, made beautifully simple designs for tea-pots, salt-cellars and other objects. The architect Godwin, who was commissioned by the Anglo-American painter Whistler to design his White House (itself inspired by the clear-cut designs of Japan), made furniture designs with tall vertical lines and right-angles in a manner that was close to the 20th-century functional style at its most incisive. The younger Mackmurdo also favoured sober linear designs with an emphasis on verticals. He sometimes introduced such Art Nouveau motifs as spiralform patterns for the backs of the chairs he designed, but he never gave himself entirely to the style. The tapestries of both Mackmurdo and Voysey simplified Morris's heavy Gothicism; the patterns were freer and more fluid, although they never reached the extremes of curvilinear arabesque characteristic of Continental works a few years later. The craftsman who made greatest use of scroll-like and interlacing lines was Richard Ashbee, who produced many pieces of silver closely resembling those made for Liberty's.

The work of Mackintosh, his friend and collaborator Macnair, and their wives, the sisters Margaret and Frances Macdonald, must be mentioned. All the furniture from their workshop was characterised by a sober pre-20th century functionalism which was the hallmark of late 19th-century English design. But

whereas Godwin's and Mackmurdo's stress on clean-cut vertical lines was occasionally exaggerated, Mackintosh's chair-backs became much more elongated—beyond the limits of 'common sense', though this, in fact, gave them an added grace and liveliness. The legs of Mackintosh's furniture were also very graceful, being extremely slender by contrast with the large bodies they were made to support. They were animated by a rhythm of oblique lines like slightly diverging branches on a tree. Above all, their phytomorphic character was made clear by the way the stem motif was repeated and the vertical lines were broken at the joints by exquisitely carved knots, entwining vine shoots and blossoming branches. This quiet and delicate use of organic motifs gave warmth to the clean-cut vertical lines of the main design.

In Europe Horta's furniture and interiors helped to consolidate the supremacy of the 'Belgian line' of which he was the principal pioneer; the wide curves and big, open parabolas and spirals he used were a great contrast to Mackintosh's vertical linear rhythms. But Horta's designs gave the same impression of equilibrium as his buildings, suggesting a kind of storm with a calm centre—in the very heart of a whirlwind of curvilinear patterns and concentric whirls.

Van de Velde had propagated the 'Belgian line' throughout Europe, but as it became diffused it became less nervous and supple, and increasingly

calm, until it finally came to rest in the strict sobriety of the rectilinear designs of the 1910s and 1920s. This tendency, as has been pointed out, was present in the work of Van de Velde himself, though he always remained faithful to complex curvilinear patterns, even if they gradually became less pronounced and decisive. His style may be summed up as a functionalism and rationalism which was ahead of its time but which was still tied to the long-enduring organic style of Art Nouveau. Examples of this dualism are his famous writing-desk, a ponderous but extremely functional and simplified object with curves which seem designed to embrace the person sitting at it; certain of his clear-cut designs for knives and forks with their functional lines enlivened with spiral decorations on the handles; the furnishings for many of the rooms of the house of Count Kessel, his indefatigable German protector and Maecenas; and Van de Velde's own residence at Weimar (which contained several masterpieces of contemporary painting) in which the sober interior decoration, with structural elements left bare, is accompanied by decorative elements with rich arabesques, interlacing patterns and skeins in flexuous, sinuous, linear rhythms. As the Belgian artist wrote: 'the external parts complete the natural organs of the object; but they are rather like grafts which can either participate in the life of the whole plant or else wither it according to the skill of the grafter.'

The Munich designers Endell and Riemerschmid also designed chairs, tables and cupboards as living bodies; but unlike Van de Velde they thought of them in terms of animals rather than plants. This led them to conceive of each element as a part of a skeleton and to unite them with complex, projecting knotty joints. Nearly all their pieces had this kind of hard, skeletal quality. As a matter of fact they had been preceded on the same path by Gaudí, who had made use of contortions, protuberances and hard massive centres reminiscent of the bone-structures of prehistoric monsters in his furniture designs for the Güell Palace.

The French applied arts, like French architecture, were behind the times; at the beginning of the 1890s craftsmen were still producing pastiches of various historical styles. Later, however, France produced some of the outstanding Art Nouveau works. The main credit for this resurgence undoubtedly belongs to the dealer Bing. He was a German who had settled in Paris at the end of 1871, and had spent many years there as a dealer and propagandist for Japanese art. But despite this specialisation he was deeply aware of contemporary artistic problems. He particularly deserves to be remembered for his courageous intervention in the controversy as to the extent to which the applied arts should be industrialised—a crucial question for Art Nouveau artists. Bing declared, 'The machine will play an important part in the advance-

34. C. R. Mackintosh (1868-1928). Table. School of Art, Glasgow. The Scots architect returned to the Anglo-Saxon tradition of solidity and simplicity in the making of furniture, which was usually designed with the accent on horizontal and vertical lines. But in Mackintosh's work vertical lines dominate and practically become an obsession. At the same time there is a hint of phytomorphic inspiration.

35. C. R. Mackintosh (1868-1928). Chair. University Art Collection, Glasgow. Another example of the artist's 'vertical' style, and of his constant striving for eccentric and irregular effects—here the reversal of the normal relationship between height and breadth in every part of the chair.

36. C. R. Mackintosh (1868-1928). Small table with circular top and square shelf. University Art Collection, Glasgow. The vertical lines have multiplied to suggest a forest of tall stems. The two horizontal planes have been brought close together, accentuating the downward thrust of the legs. The piece demonstrates the simplicity and originality of Mackintosh's style.

37. L. Majorelle (1859-1929). Guéridon. Musée des Arts Décoratifs, Paris. Majorelle was one of the leading figures in the School of Nancy which formed around Gallé. His furniture designs are distinguished by his stress on bare joints and structural elements which are inspired by plant themes.

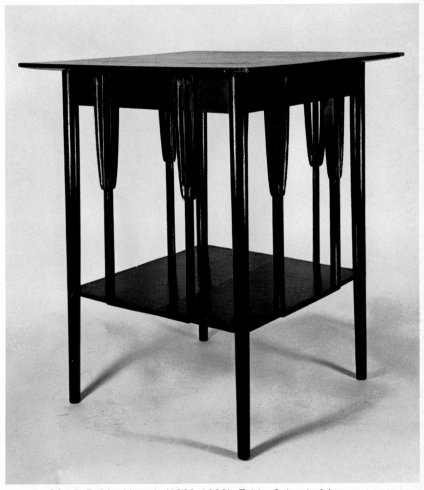

34. C. R. Mackintosh (1868-1928). Table. School of Art, Glasgow.

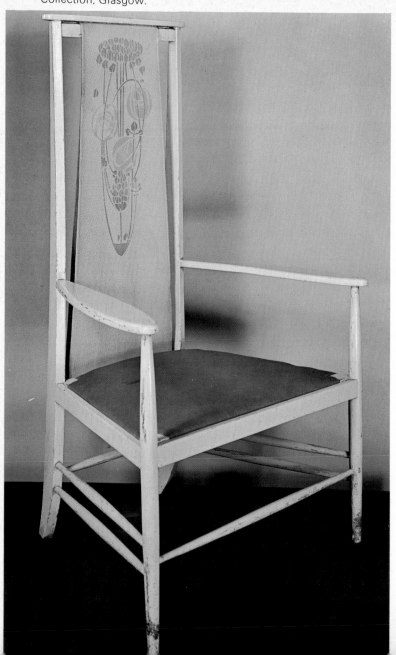

35. C. R. Mackintosh (1868-1928). Chair. University Art Collection, Glasgow.

36. C. R. Mackintosh (1868-1928). Small table with circular top and square shelf. University Art Collection, Glasgow.

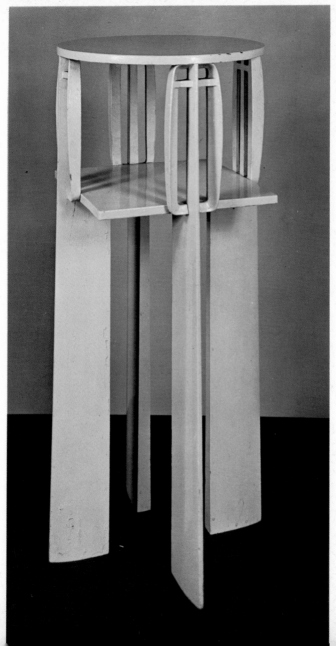

37. L. Majorelle (1859-1929). Guéridon. Musée des Arts
Décoratifs, Paris.

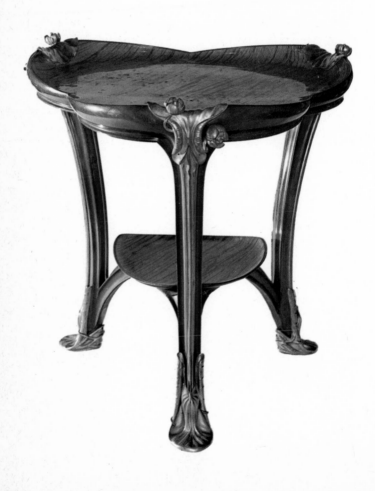

ment of public taste. Because of it the joy of pure forms will be established again and again by a principle which is both unique and of far-reaching significance.' His was a democratic programme, but its fulfilment was prevented by the high price of Art Nouveau objects, which was inevitable given their experimental character and intricacy. Consequently Bing's Art Nouveau shop, which he had founded to spread his ideas, catered only for a limited public with both money and taste. The shop became the centre for the artists who assured the success of the Art Nouveau styles in Paris: Gaillard, Colonna, De Feure and Plumet for furniture and decoration, and René Lalique for jewellery.

The main characteristic of the furniture made by these artists—and by Charpentier, who must be added to the list—was that they all followed the *style métro* quite closely, using flexuous vegetal motifs which were somewhat more subtle variations on the 'Belgian line'. The leader of the style was of course Guimard, whose direct involvement with the group was of great moment. Even Lalique's pieces of jewellery were little exercises in organic composition, extremely ingenious and original in design; the value of the metals and precious stones was less important than the overall design and colour effect achieved.

Bing was aware of the international character of the movement, and made a point of searching out the

greatest foreign talents and making them known in France. He was quick to recognise the genius of the American Louis Tiffany, and became the exclusive European agent for Tiffany's opalescent glass objects. As soon as he heard about Van de Velde's house at Uccle, Bing rushed to him to commission some works.

He also became interested in stained glass and, apart from Tiffany, employed the Nabis Bonnard and Vuillard, and Eugène Grasset. Grasset was a complex artistic personality, both decorator and illustrator, and demonstrated his grasp of the phytomorphic style of the period by writing a treatise called *La plante et ses applications ornamentales*. (He had been anticipated by Jones and Dresser, but in the intervening years the vogue for plant motifs had assumed proportions undreamed of by Grasset's English precursors.)

Another important contribution to French Art Nouveau was made by the 'School of Nancy', officially founded in 1901 but in fact active for about twenty years before. The central figure was Emile Gallé, who, like Tiffany, made vases and glass ornaments that were first-rate works of art. Gallé's creations display a typical Art Nouveau sympathy with the forces of nature, and it is said that he wanted to place the following inscription above the door of his workshop: 'Our roots lie at the threshold of the woods, in the moss near the edge of the pond.' Gallé had a feeling of oneness with nature that was tinged with mysticism;

he was a fervent admirer of the symbolist movement in literature, having verses by Poe, Baudelaire, Mallarmé and Maeterlinck engraved on his glassware. The cyclamens, dragon-flies and butterflies that he used as motifs became highly evocative, forceful and intense symbols of unknown forces. Besides Gallé, a large number of furniture makers and decorators were active at Nancy, the major figures being Prouvé, Majorelle, and Vallin (the brothers Daum were his followers in the manufacture of glass objects). Gallé himself joined the group and in his last years created an extraordinary 'butterfly bed' in which the symbolic motif of a gigantic insect dominated and almost blotted out the functional aspect of the piece.

Gallé also collaborated with Prouvé and Vallin to create a 'dining-room' (1903-1906) for the Maison Masson which is one of the crowning achievements of Art Nouveau. Gallé's worship of the magical life of the forest and the roots of growing plants was reflected in the sinuous lines of his furnishings. The same tendency is found in the work of Tiffany. As the well-to-do son of a famous New York jeweller, he was able to work in an experimental and fantastic vein, designing interior decorations, glass-ware and, above all, opalescent glass vases and knick-knacks. Extraordinary as his shapes often were, they were all distinguished by the strange and capricious lines which were the dominant features of Art Nouveau.

PAINTING AND THE GRAPHIC ARTS

Even a category like 'painting' is not entirely appropriate in a discussion of Art Nouveau. In general, Art Nouveau artists were opposed to easel painting—that is, painting executed by traditional means in order to reproduce reality, which was to be viewed as a spectacle unconnected with the environment in which the painting was placed. In the 1890s even painting was expected to be a useful art; its function was to decorate a place or building, where it must be in harmony with its total setting. Instead of oil painting artists favoured vast decorative panels executed with thin colours like tempera, often enriching the panels by inserting various materials which protruded from the picture surface to give the effect of a relief. In consequence, artists showed an extreme reluctance to use the traditional picture frame; if used at all, it was no longer intended to separate the illusive life of the picture from the surrounding reality, but to be a kind of intermediary zone uniting the painting with the rest of the environment.

The main interest of artists of the period was graphic art, since it enabled them to reach a wider public through newspaper and magazine illustrations or posters. Black-and-white and colour lithography and wood-cuts were extensively used by artists, who carried out the ideal of obliterating the distinction

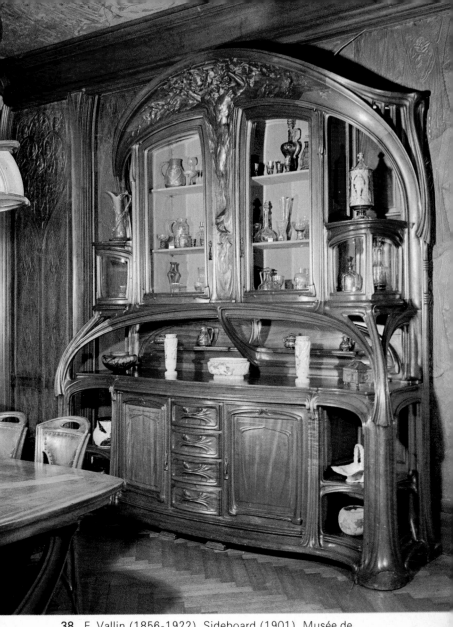

38. E. Vallin (1856-1922). Sideboard (1901). Musée de l'Ecole de Nancy, Nancy.

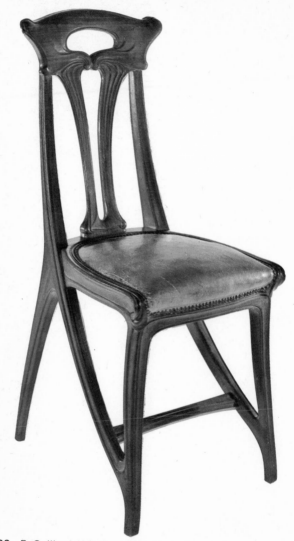

39. E. Gaillard (1862-1933). Chair. Musée des
Arts Décoratifs, Paris.

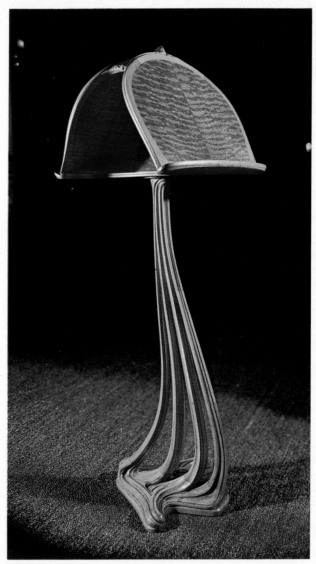

40. A. Charpentier (1856-1909). Rotating
reading-stand (1901). Musée des Arts Décoratifs,
Paris.

38. E. Vallin (1856-1922). Sideboard (1901). Musée de l'Ecole de Nancy, Nancy. Vallin, like Majorelle, belonged to the School of Nancy. His dining room, of which only the sideboard is illustrated here, is considered his masterpiece. He showed a tendency to transform furniture into ponderous variations on plant themes.

39. E. Gaillard (1862-1933). Chair. Musée des Arts Décoratifs, Paris. Gaillard was one of the artists and decorators who worked in a group centred around the dealer Bing, who inspired the most important Parisian Art Nouveau work in the applied arts.

40. A. Charpentier (1856-1909). Rotating reading-stand (1901). Musée des Arts Décoratifs, Paris. The elegant stems supporting the reading-stand seem to contain the quintessence of the Art Nouveau line: a line moving in a parabola and suddenly bursting into unexpected sinuous loops and curves.

41. H. Guimard (1867-1942). Clock. Musée des Arts Décoratifs, Paris. Guimard, the principal architect of French Art Nouveau, also worked in furniture. This monumental clock is yet another proof of his gift for elegant, flowing linear composition.

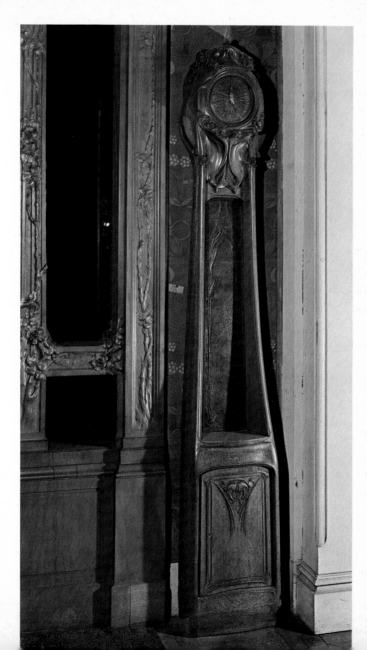

41.

between fine and applied arts by giving great attention to even the most modest details of ornamental friezes on the pages they illustrated; it was especially in such details, unconnected to a 'subject', that artists were able to indulge in the free, flowing lines of Art Nouveau. They even turned their attention to lettering, enthusiastically designing new characters.

Trends in the graphic arts were part of the general pattern noticed in the introduction to this book; they too implied condemnation of the naturalism and historicism current in the 1880s. In painting the reaction was no longer against naturalism in general but—in France at least—against the Impressionist movement, which had carried the principle of fidelity to optical impressions to its logical conclusion. By the 1890s the best French artists had therefore formulated a programme in reaction to Impressionism that was more precise than that of the preceding generation, involving extreme distortion of forms and a multi-coloured, changing, speckled play of colours and atmospheric effects. Art Nouveau was not, of course, uninfluenced by the Impressionists' emphasis on truth to nature; but instead of subordinating himself to the immediacy of visual impressions, the artist now endeavoured to order his knowledge and to extract essential forms from it.

Opposition to Impressionism could easily be mistaken for a return to historicism—that is, to the

beautiful, elevated and noble models of the past, which painters had followed only shortly before. In the 1890s the leading figures in painting were no longer Manet, Renoir or Monet but rather Gustave Moreau and Puvis de Chavannes, both artists who had enclosed themselves in a dream of splendid forms and mythical or divine apparitions and heroes. From Moreau and Puvis de Chavannes it was only a step to Dante Gabriel Rossetti and the Pre-Raphaelites in England, and to a movement in painting which was an exact counterpart of Morris's activities in architecture and design. Just as Morris had reacted to the cold eclecticism of the academic schools by championing a return to the Middle Ages, so the Pre-Raphaelites preached the adoption of the archaic forms created by painters working before Raphael and free from the sophistication and slickness of the Renaissance tradition. Although their teaching did not have any particular impact in France, where similar ideals were already being upheld by Moreau and Puvis de Chavannes, the Pre-Raphaelites had great influence in other parts of Europe. Just as Morris's teachings were behind every attempt to renew the decorative arts in the last years of the century, so Pre-Raphaelitism was behind every attempt to renovate painting.

The close affinity between Morris and the Pre-Raphaelites was also present in the negative aspects of their work. The factors which had prevented Morris

from evolving an Art Nouveau style also occurred in the case of Rossetti and the others, who were held back by an excess of analytical rigour, and a pre-occupation with description and illusion. By contrast, the new generation were striving for syntheses, freer forms and even a deliberate vagueness and unfinished quality that would add an evocative and mysterious air to the composition. But it must be admitted that it was Moreau, Puvis de Chavannes and the Pre-Raphaelites who had rejected the cult of realism and had taught the painters of the 1890s to confer qualities of nobility, esoteric beauty and elegance on paintings.

The question of whether the great Post-Impressionists (Redon, Seurat, Gauguin, Van Gogh) can be regarded as members of the Art Nouveau movement is a controversial one. In the light of the general scheme proposed in this book the answer should probably be in the affirmative; certainly no painter has a better claim to belong to Art Nouveau than Odilon Redon, a contemporary of the Impressionists, who also felt attracted by nature, the flowers, the woods, and plants, not least because he had been one of Corot's pupils in his youth. But the nature which interested Redon was not that of surface appearances, but a more profound nature which he examined as though under a microscope, listening to its every heart-beat: a nature of embryos, of seeds, of the microcosm. It was a nature like that of some magical

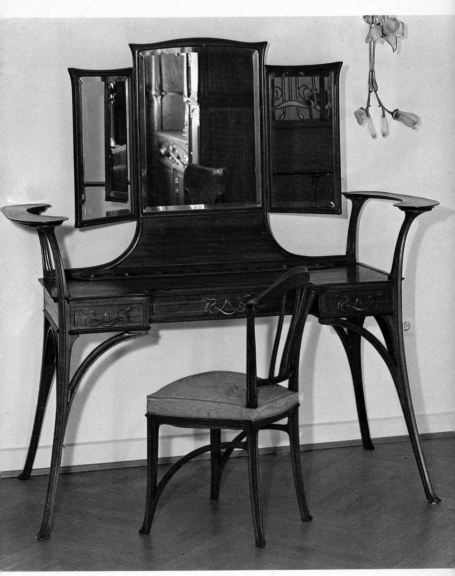

42. C. Plumet (1861-1928). Dressing-table. Kunstgewerbe-museum, Hamburg.

43.

documentary and takes them into that of design. Rather than recording the fashions of his time, Seurat was in effect proposing another, ideal and experimental, fashion.

It would be difficult to detect any inherited Impressionist characteristics in Paul Gauguin's work. His problem was not so much to give order to tumultuous elements as to simplify human silhouettes and reduce them to a synthetic linear scheme. In order to realise this aim, he made use of the teachings of Puvis de Chavannes and the Pre-Raphaelites, who recommended artists to revert to the style and technique employed before Raphael. But Gauguin was too conditioned by his first teacher, Pissarro, and by Impressionism in general, to abandon himself totally to such a precious form of primitivism; and the persistence of naturalistic influences in his work is demonstrated by the duration of his respect for the plasticity of figures and objects. The turning-point in his career was his friendship and collaboration with the young Emile Bernard, with whom he stayed at Pont-Aven in Brittany in 1888. Their encounter led to the formation of the School of Pont-Aven, which was of fundamental importance to the development of modern painting. The more imaginative Bernard employed free linear patterns, derived from the study of the Primitives, with far more confidence, and he used uniform colour planes enclosed by heavily

emphasised outlines or *cloisons*. This was the beginning of Synthetism, known in France as Cloisonnisme.

The first major painter to draw part of his inspiration from the School of Pont-Aven was Gauguin's tortured friend Vincent Van Gogh, whose spiritual preoccupations made him ill-adapted to the positive and concrete style of Impressionism or Divisionism, which he had tried to adopt after abandoning the gloomy Naturalism and 'populism' of his early period. But although Van Gogh found liberation in the use of curvilinear lines, haloes and rays of light around the suns, moons and cypress trees, his other characteristics were quite unlike those of the School of Pont-Aven. In particular, he was always extremely sensitive to the tangible presence of paint, which led him to work in an increasingly thick and tormented *impasto*. Such characteristics were alien to the linearism and use of flat areas of uniform colour found in Synthetist painting. For this reason, Van Gogh had less connection with Art Nouveau than any of the other great French Post-Impressionists, with the possible exception of Cézanne, who seemed to stride right over the *fin de siècle,* preparing the way for such characteristic styles of the early 20th century as Cubism and Constructivism. Cézanne's situation was analogous to that of Perret and Loos, who bypassed the floral styles of their time and directly anticipated the geometrical designs of the future.

The School of Pont-Aven was represented less by the minor artists gathered around Gauguin and Bernard in Brittany than by a group of young Parisian artists, many not yet twenty years old, who received Gauguin's teachings through one of their comrades, Paul Sérusier. Sérusier knew Gauguin well, and from their collaboration was born the famous *Talisman,* a little landscape composed in scrupulous conformity with the principles of the Synthetists. The young artists Maurice Denis, Paul Ranson, Ker Xavier Roussel, Pierre Bonnard and Edouard Vuillard, like their contemporary Bernard, moved in a mystical atmosphere that was determinedly hostile to the positivism and prudent materialism which seemed to inspire contemporary bourgeois life and ethics. They dreamed of founding a community which would reject and ignore society. They turned sometimes towards medievalism, sometimes towards exoticism, calling themselves the 'Nabis', the Hebrew term for 'prophets', and devising elaborate rites and ceremonies. Though at first sight such a movement might seem merely a kind of retarded Pre-Raphaelitism, there was a striking difference between the two communities: the Pre-Raphaelites were dominated by the spirit of analysis, the Nabis by the spirit of synthesis and simplification. Whereas the Pre-Raphaelites cultivated their ideals with puritan strictness, proclaiming the triumph of ideas and the spirit over nature and the

flesh, the Nabis displayed a certain humorous reserve towards their own ceremonies, and wished to establish a bridge between nature and ideas, flesh and spirit. In accordance with the literary tendencies of the time, the term 'symbol' became their key-word, used to ratify the alliance between nature and spirit. The Nabis therefore emphasised the surfaces of paintings and the way in which lines and figures were disposed —not so much for their own sake but, as Denis and Sérusier stated in their writings, because the more pure and essential they were the more they would evoke the values of the non-material world. The attention they paid to the organisation of lines and colours was not limited to easel painting but extended to all surfaces—walls, screens, textiles, tapestries, stained-glass windows, illustrations and posters, in all of which the Nabis worked with enthusiasm and success. They also had the good fortune and the discernment to be associated with the first manifestations of the new Symbolist theatre. They were friendly with Lugné-Poë, the founder of the Theatre de l'Oeuvre, and made contributions to productions of plays by Maeterlinck, Jarry and Ibsen according to their various capacities as scenic, programme and costume designers. Such an intensive theatrical activity on the part of painters has only been found since in the contribution made by Russian artists to Diaghilev's ballets.

46. E. Grasset (1841-1917). Spring (1884). Stained-glass window. Musée des Arts Décoratifs, Paris.

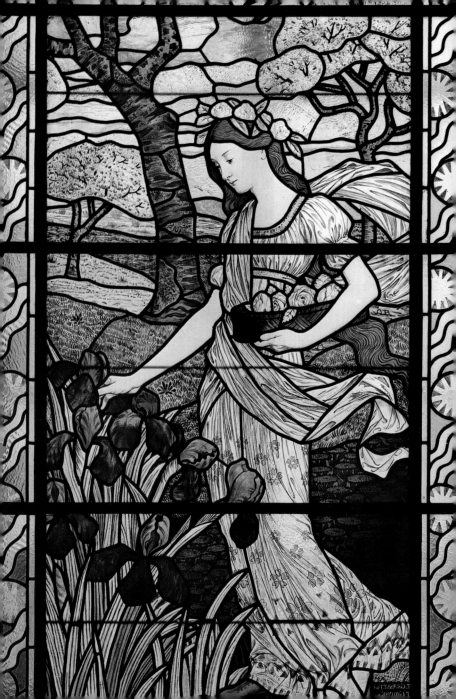

47. H. Toulouse-Lautrec (1864-1901). Moulin Rouge—La
Goulue (1891). Poster. Musée d'Albi.

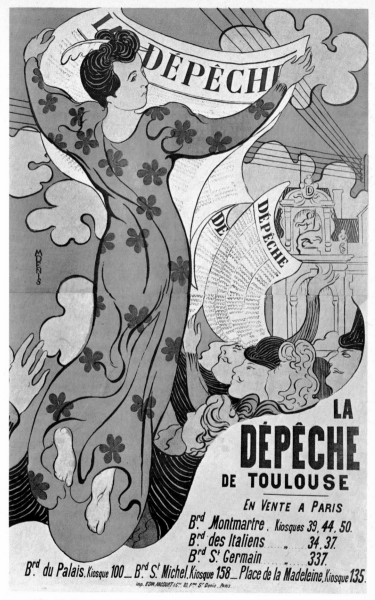

48. M. Denis (1870-1943). La Dépêche de Toulouse.
Poster. Library of the Musée des Arts Décoratifs, Paris.

46. E. Grasset (1841-1917). *Spring* (1844). Stained-glass window. Musée des Arts Décoratifs, Paris. Grasset was one of the most important Art Nouveau interior decorators working in Paris, and the author of a treatise, *La plante et ses applications ornamentales,* which made a notable contribution to the movement. One of the many mediums he worked in was that of stained-glass which, like tapestries and posters, was particularly suited to the art of the time.

47. H. Toulouse-Lautrec (1864-1901). *Moulin Rouge—La Goulue* (1891). Poster. Musée d'Albi. The celebrated poster for the Moulin Rouge in which Toulouse-Lautrec showed how the technique of the poster was the most suitable for attaining 'synthesis'. On the other hand, Toulouse-Lautrec's own personal synthetic style was always documentary in intention which distinguished it from the more specialised forms of Art Nouveau which was characterised by a greater degree of freedom and abstraction.

48. M. Denis (1870-1943). *La Dépêche de Toulouse.* Poster. Library of the Musée des Arts Décoratifs, Paris. © SPADEM, Paris, 1967. Denis's poster, unlike Toulouse-Lautrec's, is typically Art Nouveau, for its sinuous lines and profiles have nothing in common with the utilitarian documentary purpose which inspired it. Denis, who was one of the leading Nabis, had in fact expressed the belief that the artist had the right to reject the dictatorship of narration.

49. F. Vallotton (1865-1925). *L'été—le bain.* Kunsthaus, Zurich. © SPADEM, Paris, 1967. Vallotton, a Swiss artist who settled in Paris, worked in a style half-way between that of Toulouse-Lautrec and that of Denis. Like Lautrec, Vallotton showed himself to be a talented chronicler and observer of everyday life; but he was also an elegant stylist, which made him welcome in the ranks of the Nabis.

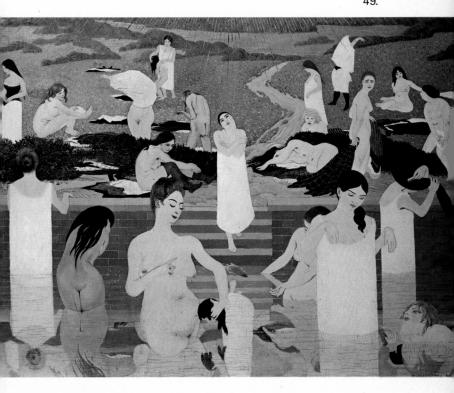

Maurice Denis's style consisted of an exquisite basic pattern of curved lines and floral motifs which were intended to exalt certain mysteries of the Catholic religion *(Soir trinitaire, Le mystére de Pâques)* as well as to celebrate certain secular mysteries *(Les Muses, La marche des fiançailles)*. Sérusier combined popular and folk-lore elements with themes of grace and charm taken from Medieval legend. Paul Ranson's inspiration, on the other hand, was decidedly secular and topical. He may be considered the leader of the group, not least because he held the meetings of the Nabis in his own studio (which was dignified with the hieratic name of 'temple'). Ranson was perhaps the outstanding exponent of the 'linear' style then working in France, painting with an elegance and freedom that ennobled the themes he took from everyday life, even one as trivial as his *Potato peelers*. He found the best outlet for his talent in a series of fantastic and exotic cartoons which he drew for tapestries.

As is well-known, Bonnard and Vuillard gradually moved away from the common programme of the group and began to paint 'intimate' and everyday scenes. But at the beginning of the 1890s they were quite willing to escape from the confines of easel painting to work on a larger scale. Bonnard particularly distinguished himself in one of the most important branches of graphic art: poster design. Admittedly poster art was already fashionable (thanks to the work

of Jules Chéret, its first great exponent); but when, in 1891, Bonnard was commissioned to design a poster for the wine firm of France-Champagne, the boldness of his synthetic and simple design, with its blurred outlines like figures in a shadow show, marked an important step forward for the poster as an art. His achievement had a great influence on another artist who was in other respects working towards quite different ends: Toulouse-Lautrec.

In recent times two opposing tendencies have been detected in Toulouse-Lautrec's work. On one hand he was the heir of Manet and Degas: like them, he aimed at giving a complex picture of 'modern life' by recording typical scenes of public life and catching the everyday atmosphere of the time. But on the other hand, he was trying to simplify his visual world by the use of clear-cut, lively and highly expressive linear forms. The vast number of posters he designed for the Moulin Rouge, the Jardin de Paris and other public places, and for cabarets and cafés, gave Toulouse-Lautrec a wonderful opportunity to develop the 'shadow show' side of his art and to compose a series of beautifully economical, compact scenes. His achievement was only of marginal relevance to the development of Art Nouveau, however, since his linear style contained none of the floral motifs or the voluptuous organic qualities characteristic of Art Nouveau. Lautrec remained faithful to the ideals of

Manet and Degas; he was one of the greatest masters of the painting of modern life.

An analogous spirit of observation occurs in the work of Félix Vallotton who, though a Nabi, remained somewhat apart from the rest of the group, one reason being his Swiss origin. He was the most active graphic artist among the Nabis, executing a long series of wood-cuts for the *Revue Blanche* and other magazines. But fidelity to the documentary approach and the recording of contemporary life did not prevent him from working in a style characterised by sinuous linear rhythms, capricious black-and-white patterns, and an interplay of full and empty spaces. All these features made Vallotton's art a curious kind of 'Art Nouveau with its feet on the ground': an art in which even the freest and most unrestrained imaginative fantasy could be integrated with everyday reality. The same can certainly not be said of another foreign artist, the Czech Mucha who, like so many others, had been drawn into the glittering orbit of Parisian art. Mucha became an extremely popular poster artist in the 1890s. His art had little of the synthetic spirit; his main talent was for designs featuring beautiful and heavily ornamented women arrayed in Oriental splendour.

The influence of France was widely felt in painting and the graphic arts in other countries. The most stimulating of these influences were Divisionism and

50. A. Mucha (1860-1939). Gismonda. Poster for the Théâtre de la Renaissance, Paris. Civica Raccolta Bertarelli, Milan.

GISMONDA

BERNHARDT

THÉÂTRE DE LA RENAISSANCE

IMPRIMERIES LEMERCIER PARIS

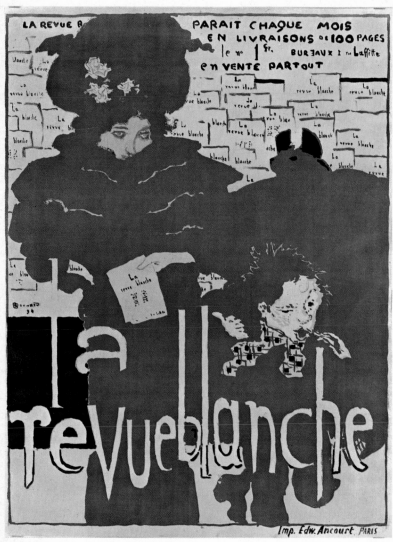

51. P. Bonnard (1867-1947). Poster for the 'Revue Blanche'.

52. P. Ranson (1864-1909). Woman in Red. Ranson Collection, Paris.

50. A. Mucha (1860-1939). *Gismonda*. Poster for the Théâtre de la Renaissance, Paris. Civica Raccolta Bertarelli, Milan. An example of the kind of poster that made Mucha famous. The elegance and decorative opulence of the costume is far superior to the figure of the woman.

51. P. Bonnard (1867-1947). Poster for the *Revue Blanche*. © SPADEM and ADAGP, Paris, 1967. The poster was the result of an encounter between one of the most gifted artists of the *fin de siècle* and the Parisian review most disposed to welcome the leading spirits of the age. Bonnard's poster is an unsurpassable example of 'synthetic' composition at its best; at the same time, like Toulouse-Lautrec's posters, it shows close observation of everyday reality.

52. P. Ranson (1864-1909). *Woman in Red*. Ranson Collection, Paris. Paul Ranson was a member of the Nabi group. He developed the principles laid down by the Nabis elegantly and logically by means of flat colour planes and flowing, serpentine outlines.

53. O. Redon (1840-1916). *Pandora* (*c.* 1910). Oil on canvas. Metropolitan Museum of Art, New York. Alexander M. Bing Bequest, 1959. © SPADEM, Paris, 1967. As always in Redon's work, linear grace—in this painting of the woman's face—is combined with an intense vibrancy of detail. The work dates from the artist's 'happy' period, characterised by brilliant colouring.

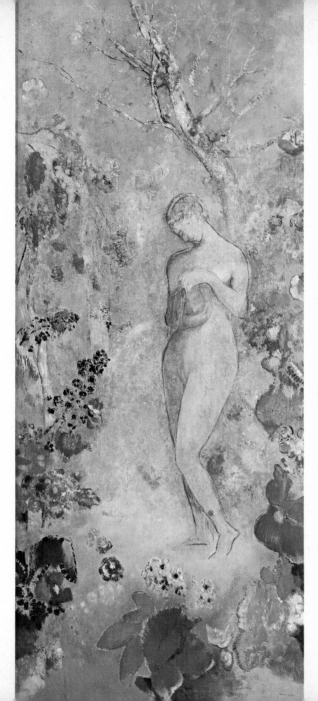

53.

the Pont-Aven school. Often the two styles were employed by an artist at different periods of his career. Van de Velde, for example, began his career in about 1890 as a Divisionist, later switching to the linear style of the 'Belgian line' in posters and illustrations which showed his indebtedness to the Pont-Aven school. Similarly, the Dutch artist Jan Toorop alternated between loyalty to Divisionist principles and elegant stylisation in which he made use of hieratic female images in unusual and exotic compositions inspired by the arts of his original home, Java. The enigmatic priestesses in such paintings as *The Three Wives* and *Death, Where is Thy Victory?* have hard angular profiles and luxuriant flowing tresses; every corner of the composition is filled, as though to indicate the artist's profound *horror vacui*. But exotic as his forms were, Toorop had no difficulty in making them serve such a vulgar purpose as advertising new products. This is yet another proof that even when they preached a new, rarer form of beauty, Art Nouveau artists had no intention of reserving it for a chosen few.

Seurat and Gauguin also influenced Edvard Munch, the leading Scandinavian artist of the period. When he arrived in Paris in 1890, he had been already conditioned by the heavy-going, dramatic naturalism of the 'Cristiana bohème', a kind of artistic and literary bohemianism inspired by, among other things, Zola's

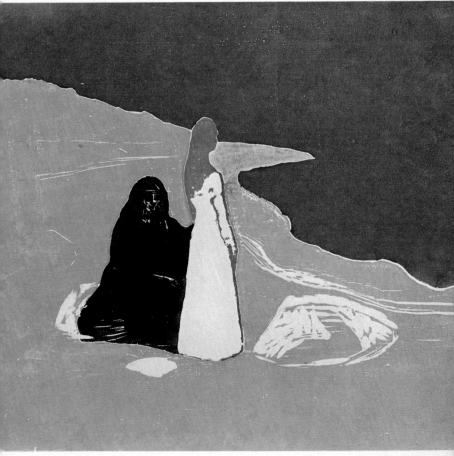

55.

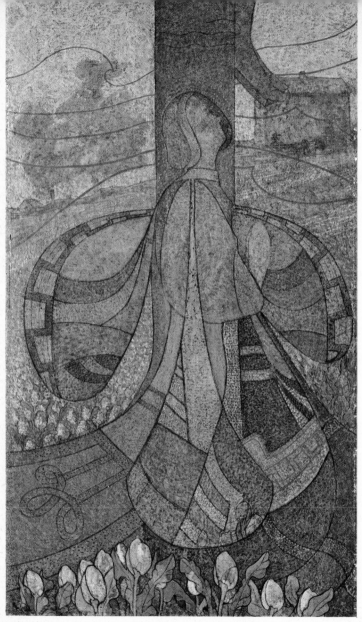

56. J. Thorn Prikker (1868-1932). The Madonna of the
Tulips (1892). Rijksmuseum Kröller Müller, Otterlo.

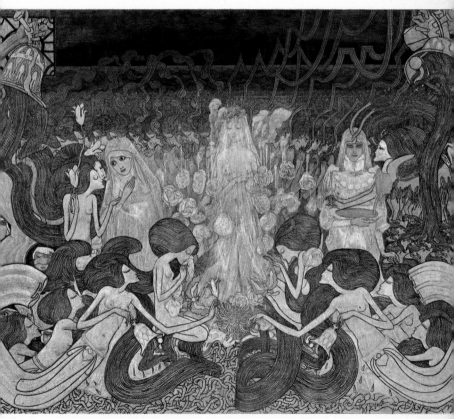

57. J. Toorop (1858-1928). The Three Wives, Rijksmuseum
Kröller Müller, Otterlo.

de chine illustrations for reviews and magazines like *The Studio, The Yellow Book* and *The Savoy,* or literary works like Oscar Wilde's *Salomé,* had an ostentatiously libertine and profane character. They seemed to invite the spectator to abandon every restraint imposed by common sense and Victorian morality in favour of a new life which would be free from bourgeois prejudices and offer the most seductive prospects. Such artistic intentions were radically different from those of the Pre-Raphaelites and in complete opposition to their puritan spirit. Beardsley's style was correspondingly different, for instead of the analytical spirit and meticulous attention to detail which characterised the work of Rossetti and Burne-Jones, his pen-and-ink drawings celebrated the triumph of the synthetic style, their stark lines flowing freely across the page, unhindered by any kind of ornamentation or disguise. The stark simplicity of Beardsley's line brings to mind the structural elements which the best Art Nouveau architects insisted on leaving bare. But at the same time, although Beardsley's highly personal line was capable of straying into the most unexpected arabesques, it was also striving after a difficult and precarious equilibrium. Such a linear style clearly revealed the vitalistic enthusiasm that had inspired it, bursting out into exuberant, decorative arabesques, clusters and sprays before resuming its arrow-sharp trajectory. Such extreme freedom and elegance of linear composi-

tion was only to be found again in British art in the work of Mackintosh and the Macdonald sisters.

Another European country which was not directly influenced by Synthetism and Divisionism was Germany, which had only just discovered Impressionism. The new forces at work found expression only in the Munich and Berlin Secessions, and in the magazines *Jugend* and *Pan*. There were two different tendencies in the Secessionist revolt. One more or less conformed to what was meant by the 'Secession style'—that is, a kind of historicising eclecticism in which classical, romantic, visionary and exotic elements were blended according to a largely traditional and static conception of painting. Such a tendency was particularly noticeable in the work of artists like Max Klinger or Fritz von Stuck who—and this was no coincidence—became widely known.

The other, more advanced tendency was the rejection of easel painting in favour of decorative or applied art. Two of the artists who most distinguished themselves in this direction were Hermann Obrist and Otto Eckmann. Obrist was a complex and striking figure; he made some of the most interesting sculptures of the period, was a graphic artist, and tried his hand at textile embroidery. One of his most famous works was a highly stylised *Cyclamen* which, like some of the glass pieces by Gallé and Tiffany, was one of the most symbolic and representative examples of the

spirit of Art Nouveau. Eckmann, by contrast, made systematic use of ribbon-like floral patterns on every available occasion, in the decoration of textiles, wallpapers, friezes and newspaper vignettes. Mention must also be made of the caricatures which Thomas Theodor Heine, Bruno Paul and the Swede Olaf Gulbrasson drew for *Simplicissimus,* the famous satirical paper published at Munich. In this case the main source of inspiration was Beardsley's distilled linearism.

The Viennese artist Gustav Klimt also belongs to the Secession movement by virtue of elements that appeared in his paintings: monumental forms which still showed classical and academic inspiration, and human bodies with swelling, strongly stressed muscles. The latter were particularly noticeable in one of Klimt's largest and most famous decorative works, the series of symbolic panels *(Law, Medicine, Philosophy)* painted for the University of Vienna. But unlike many other Secessionists, Klimt avoided academic ponderousness by the highly ingenious and imaginative way he placed forms in his compositions. His figures would appear entwined together in complicated chain-patterns, or reclining spectacularly, or falling at oblique angles across the compositions. And as a contrast to such contortions, Klimt filled the rest of the painting with some of the most intensely vibrant patterns of detail created in the whole Art

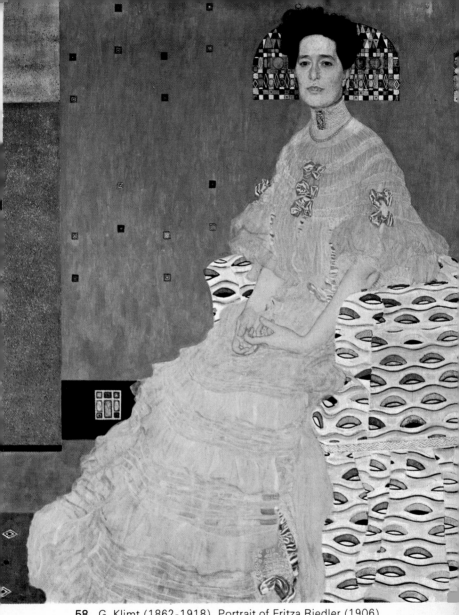

58. G. Klimt (1862-1918). Portrait of Fritza Riedler (1906) Österreichische Galerie, Vienna.

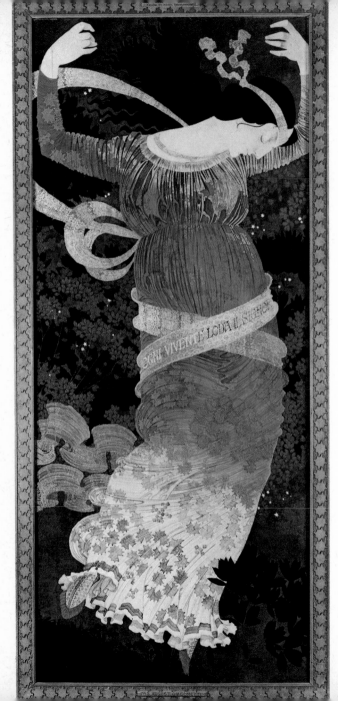

Nouveau period: peacocks' feathers, spirals, flowing tiles and bricks, rhomboids. They overflowed in mosiac-like profusion, in sweeping and vibrating rhythms which were never arbitrary or casual but always subject to strict control: Klimt's dazzling images of chaos and disorder were in fact obtained by an infinite multiplication of ordered elements.

The same ponderous stylised bodies appeared in the work of the Swiss Ferdinand Hodler; their effect was also modified by decorative counterpoints of garlands of flowers and green plants. But in Hodler's case the decorative element was far more restrained, and never overwhelmed his characteristic austerity and gravity. He had retained these characteristics from a long period in which he had worked in a robustly naturalistic vein, using peasant and folk-lore themes. It was not until 1890 that he succeeded in transforming his gloomy figures of peasants, workmen and beggars into symbols of human anxieties and interrogations of human destiny, as in his most famous painting, *Night,* which was quite warmly received when shown in Paris.

An evolution similar to Hodler's was taking place at the same time among artists in Italy. Although at the time it did not receive the attention is merited, it represented one of the most decisive moments in the history of modern Italian art. The main artists concerned were Giovanni Segantini, Gaetano Previati

60. A. Giacometti (1868-1937). Night (1903). Kunsthaus, Zurich.

and Giuseppe Pellizza de Volpedo. They had begun working in a realistic vein, composing anecdotal scenes of everyday life in a typically atmospheric Lombard style. Towards the end of the 1880s they came under the influence of the French Divisionists and began to feel the need to give their work a greater discipline and to use a more clear-cut, precise technique. At the same time they became aware of the insufficiency of the small everyday verities which had inspired them, and aspired to create an art which would convey a message of universal import. It was then that they came under Pre-Raphaelite influence which suggested the use of a greater beauty and elegance of line in contrast to the vaporous shapes and languid, refined colouring of the Lombard school. The first result of this change was Previati's *Maternità* of 1891. This was an important date in modern Italian art. *Maternità* caused its first official scandal, for when it was first exhibited at the Brera it met with almost unanimous condemnation—despite the fact that it was one of the few Italian paintings of the late 19th century to approach the best European works. Segantini, who had hitherto been a naturalist, then followed Previati along the new path, displaying greater energy and creativity than his friend. Another artist starting his career at the time was Pellizza, who proved himself the most measured and precise of the three artists in the course of his brief but intense

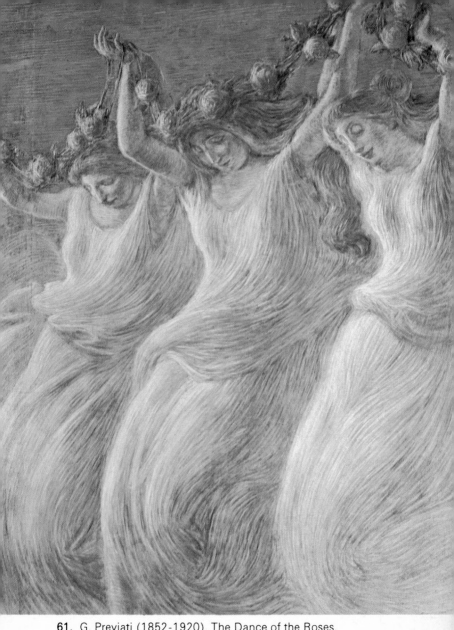

61. G. Previati (1852-1920). The Dance of the Roses.
Vittoriale, Gardone.

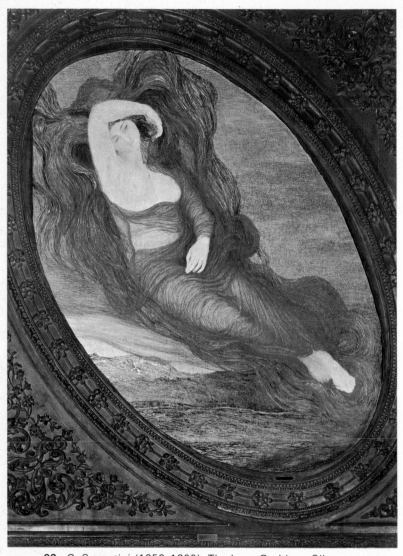

62. G. Segantini (1858-1899). The Love Goddess. Oil on canvas. Galleria Civica d'Arte, Milan.

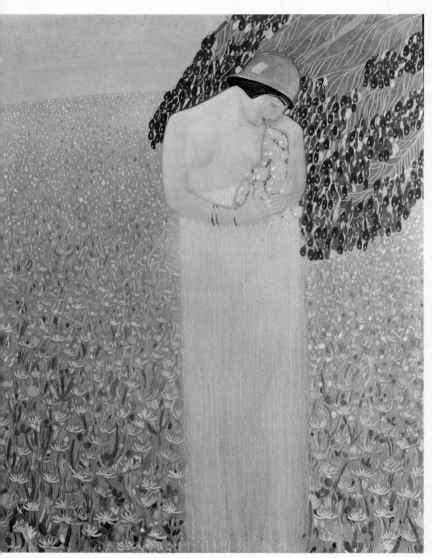

63. F. Casorati (1886-1963). Per sè e per il suo ciel concepe e figlia. Tempera. Galleria Narciso, Turin.

61. G. Previati (1852-1920). *The Dance of the Roses.* Vittoriale, Gardone. Previati was perhaps the most 'experimental' of late 19th-century Italian painters. The mystic tone and use of undulating lines of the English Pre-Raphaelites influenced him, but as he could never shake off the influence of the Lombard school he treated Pre-Raphaelite themes with greater freedom and more delicate modelling.

62. G. Segantini (1858-1899). *The Love Goddess.* Oil on canvas. Galleria Civica d'Arte, Milan. Segantini began his career by working in a naturalistic style, using Divisionist techniques. After 1890 he came under Previati's influence and began to work in an Art Nouveau manner. This painting is one of the most characteristic examples of his second style.

63. F. Casorati (1886-1963). *Per sè e per il suo ciel concepe e figlia.* Tempera. Galleria Narciso, Turin. Before working in his well-known Metaphysical manner, Casorati was influenced by Art Nouveau, as in this painting with its masses of flowers and typical linear stylisation of the female figure.

64. A. Maillol (1861-1944). *Flora.* Kunstmuseum, Wintertur. © SPADEM, Paris, 1967. The full, heavy plasticity of Maillol's sculpture seems a long way from an affinity with Art Nouveau; but this can be observed in the smooth flow of the lines and the symbolic character of all Maillol's nudes, who were intended to represent the spirit of Nature.

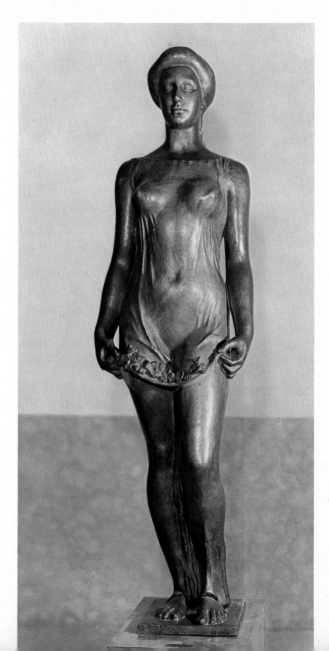

64.

career. His work illustrated the closeness of the links between Divisionism and Symbolism, natural themes and social-humanitarian themes.

Other Italian artists worked in a manner suggested by the most superficial aspects of the Secession. One was the then famous Aristide Sartorio, whose work displayed all the vices that Art Nouveau was trying to discard: eclectic academicism and badly digested historicism and exoticism. A more coherent and openly historical-minded artist was Adolfo de Carolis, who painted monumental decorations for public buildings after having shown Pre-Raphaelite inspiration in his youthful work. As pointed out earlier, Italian Art Nouveau still needs thorough investigation. In the meantime, it is worth remembering that all the main figures of the Italian Futurist movement —Balla, Boccioni, Romano, Russolo, etc.—made frequent use of Secessionist elements in their early work.

SCULPTURE

Sculpture was the least important of the major arts in the Art Nouveau period. Very few artists practised sculpture as an independent activity, unrelated to some general scheme of decoration or furnishing. Rather than marble or clay works, the true plastic masterpieces of the time were to be found in the

opalescent glass vases of Gallé and Tiffany, the wrought-iron railings and balustrades of Gaudí and Guimard, and the furniture of Majorelle and Vallin.

Of the few artists who were sculptors in the fullest sense, the most outstanding was the Frenchman Aristide Maillol. But even Maillol had begun as a graphic artist and painter; he had imbibed Gauguin's teachings at Pont-Aven and worked so closely in accordance with the theories of the Nabis that some writers have considered him a member of the group. Maillol also encouraged his Nabi friends to revive the craft of tapestry-making, which he had organised on a workshop basis. Whether he worked as an illustrator or as a tapestry designer, Maillol respected the canons of Synthetism, the curvilinear style and the use of mythological themes—characteristics that he was later to translate into three-dimensional terms. The fact that his sculpture is still appreciated is due to the extent to which he made use of rhythmic curvilinear lines, flexuous and curved profiles. The interest of his work declines in his later period, after he had gradually abandoned his first manner in favour of a more static Mediterranean Neo-Classicism. Maillol deserves his fame rather for the beautifully curved, sinuous works of his early period, for example *Washerwoman,* than for such works as the turgid *Pomona* and *Flora* of his central phase.

Another artist who specialised in sculpture was the

Belgian Georges Minne. Minne was as Nordic, ascetic and puritanical as Maillol was Mediterranean, sensual and carnal. In contrast to the beautiful, rounded female figures of the French artist—symbolising nature at its warmest and most vital—Minne's sculptures were of sunken-eyed, emaciated youths or weeping women: images of sadness and pain in contrast to Maillol's spirit of serene integration with nature. But Minne's kneeling, praying youths are never represented in a state of abandoned grief; to judge from the languid elegance of their poses, they would find comfort in the ascetic ritual in which they are participating.

The artist who most strikingly pin-pointed the crisis in sculpture was the German Hermann Obrist. It was he who made the most assured and coherent gesture of revolt against the Renaissance tradition—completely excluding the human figure from his sculptural works. To judge the revolutionary significance of such a gesture it is enough to know that this was the period when the genius of Auguste Rodin was most active, creating works which aimed at the romantic exaltation of a superhuman race of heroes and titans. Although Rodin's sculpture often had a corrosive 'unfinished' aspect, the object was always to stress the inner *terribilità* of his creations, not to reduce the importance of the individual. When, however, Obrist designed his *Monument for a Column,* he

completely excluded anthropomorphic motifs. What he did was to bring sculpture into line with the arts of the architect, the designer and the interior decorator, none of whom would have supposed that representation of the human figure was essential to the beauty of a staircase, a chair, a vase or a stained-glass window.

If sculpture was rarely a specialised activity, it was practised as a side-line by many painters. The first was Gauguin, who carved the folk-lore themes of Brittany and the South Seas on to vast wooden bas-reliefs, the head-boards of beds, and wall panels. His example was quickly followed by the Nabi Georges Lacombe, who brought greater refinement to his master's always rather rough and heavy forms. Another member of the Pont-Aven school, the Danish artist Willumsen, also created reliefs and three-dimensional works. The Belgian Alfred Khnopff and the German Max Klinger practised sculpture on occasion, but in a massive, hieratic style with a somewhat retrogressive Pre-Raphaelite inspiration. The work of the Frenchmen Raoul Larche and Paul Roche had no great stylistic value but left posterity a record in bronze of Loïe Fuller's famous dance—a sinuous dance of veils performed under the changing lights created by reflectors; a dance which was itself an Art Nouveau creation, and a kind of symbol of the whole age. The sculptor Leonardo Bistolfi showed himself

to be fully as talented as his Italian countrymen, Segantini, Previati and Pellizza. Although his work —especially his vast output of funerary statues— appeared rather traditional and academic in spirit, he did give his figures languid, drooping poses reminiscent of the plant forms of Art Nouveau.

CONCLUSION

As late as 1960, Leonardo Benevolo, the author of a history of modern architecture, could write: 'The period of which we are speaking is at the same time very near to us and very remote from us: less than fifty years have elapsed, many of the leading figures of the age—for example Perret, Hoffmann and Van de Velde—died only a few years ago; yet we have the impression that we are dealing with something that happened in the remote past.'

This was true at the time of writing; it mirrored the critical attitude towards Art Nouveau that prevailed in the middle of this century. Only in the last few years have art historians begun to revise their attitudes. 20th-century movements such as Rationalism and Functionalism, Cubism, Futurism and Constructivism all examined the immediately preceding period in the light of their own interests. Their adherents were ready to praise Art Nouveau for its

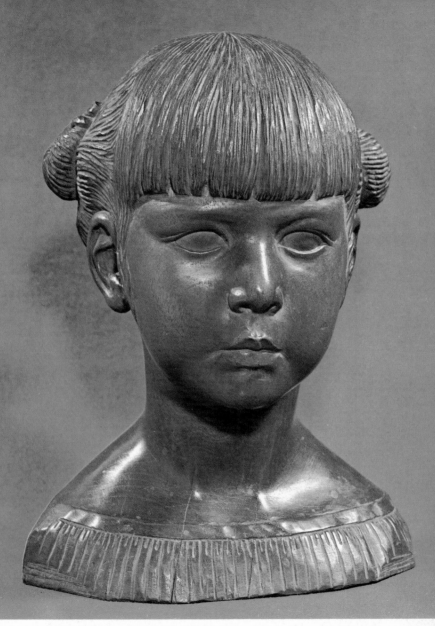

65. G. Lacombe (1868-1916). Bust of Silvia Lacombe. Wood sculpture. Lacombe Collection, Paris.

65. G. Lacombe (1868-1916). *Bust of Silvia Lacombe*. Wood sculpture. Lacombe Collection, Paris. Lacombe was one of the Nabis; like all his friends he came under the powerful influence of Gauguin, especially in his sculpture. This was the piece in which he moved furthest away from his master.

66. G. Minne (1866-1941). *Mother Crying over her Two Dead Sons*. Musée Royal des Beaux-Arts, Brussels. This was one of the Belgian artist's favourite themes; like other works—for example his figures of kneeling girls—it is imbued with the spirit of mysticism and asceticism.

67. P. Roche (1855-1922). Loïe Fuller. Musée des Arts Décoratifs, Paris. Loïe Fuller was famous for the dance of the veils she performed at the Folies Bergères. She soon became a living symbol of contemporary taste for sinuous, undulating forms, and was often painted and sculpted by artists.

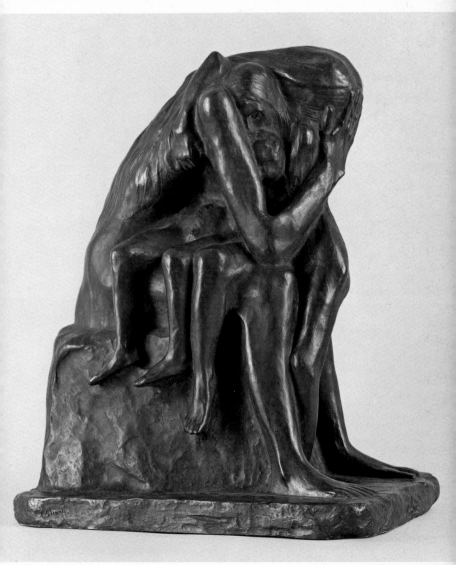

66.

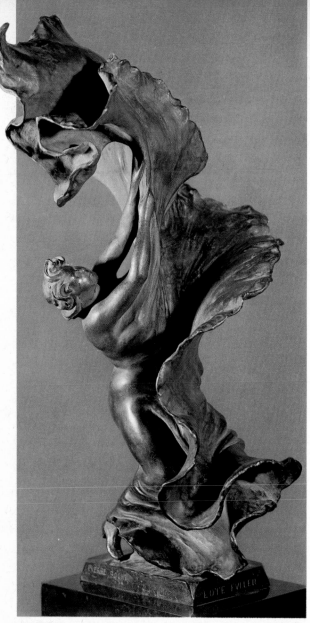

67. P. Roche (1855-1922). Loïe Fuller. Musée des Arts
Décoratifs, Paris.

movement towards a basic, synthetic simplicity of forms freed from the shackles of naturalism and historical tradition; but they also condemned it for its inability to free itself from subjection to nature and an obsession with curvilinear, floral lines and motifs. In effect, the 20th century was judging Art Nouveau in the light of its own needs and its own sources of inspiration, neglecting the actual motives and aspirations of Art Nouveau artists. Such an attitude may have been necessary if modern art was to free itself from the domination of the past; but it is not the attitude of the historian. He must point out that though Art Nouveau did move towards a certain essentiality and synthesis of forms, they were not sought for as values in themselves; this was to be the preoccupation of the early 20th century. In the *fin-de-siècle* period, functional sobriety resulted from a striving for harmony with 'nature' or some other vaguely defined entity which was held to constitute part of human experience. Whereas the early 20th century conceived of man as an autonomous being able to plan rationally in order to avoid injury by elements outside his control, Art Nouveau artists believed in a humanity convinced of its heteronomy, of the necessity to enter into a mystical harmony with what was other than oneself.

It became possible for 20th-century culture to re-examine the earlier, largely negative judgement passed

on Art Nouveau when belief in the possibility of a purely rational world had begun to decline. During the 1940s and 1950s there was a revulsion against geometrical forms in the figurative arts (visible, for example, in the popularity of abstract expressionism), and a growth of metaphysical and technical preoccupations which had affinities with those of Art Nouveau artists. Towards the end of the 1950s the new objectivity of 'Pop art' again focused attention on the everyday urban and domestic scene, on everyday objects and events. In order to do so, Pop art made use of the techniques of poster art, the graphic arts and advertising. Again there was a triumph of line, of sharp-cut profiles, and of the graphic, refined transcription of objects of common use. Thus a re-examination of Art Nouveau poster design, with its exaltation of modern life, became possible.

The same process of re-evaluation was repeated in architecture and design. As early as the 1930s there was a widely felt dissatisfaction with the rigid rationalism of the preceding decade. As this feeling grew, architects and designers felt the need to adopt more flexible instruments and to achieve a new organic harmony with environment and landscape. Finally, in recent years, a kind of neo-Art-Nouveau ideal has been put forward, and the problem of a direct relationship with the hitherto neglected movement has been explicitly raised.

The present revival of interest in Art Nouveau carries the danger of degenerating into mere collecting or sterile imitation. It would be ironical if Art Nouveau, whose practitioners intended to put an end to historicising, should provide the latest example of it. But if kept within its proper limits and, above all, in historical perspective, the vogue for Art Nouveau may be something more than a capricious phenomenon of taste.

LIST OF ILLUSTRATIONS Page